Drawing
from Within

Unleashing Your
Creative Potential

Nick Meglin with Diane Meglin, DCSW

NORTH LIGHT BOOKS
CINCINNATI, OHIO
www.artistsnetwork.com

Other fine North Light Books are available from your local bookstore, art supply store or visit our website at www.fwpublications.com.

12 11 10 09 08 5 4 3 2 1

DISTRIBUTED IN CANADA BY FRASER DIRECT
100 Armstrong Avenue
Georgetown, ON, Canada L7G 5S4
Tel: (905) 877-4411

DISTRIBUTED IN THE U.K. AND EUROPE BY DAVID & CHARLES
Brunel House, Newton Abbot, Devon, TQ12 4PU, England
Tel: (+44) 1626 323200, Fax: (+44) 1626 323319
Email: postmaster@davidandcharles.co.uk

DISTRIBUTED IN AUSTRALIA BY CAPRICORN LINK
P.O. Box 704, S. Windsor NSW, 2756 Australia
Tel: (02) 4577-3555

Library of Congress Cataloging in Publication Data
Meglin, Nick.
 Drawing from within : unleashing your creative potential / by Nick Meglin with Diane Meglin. -- 1st ed.
 p. cm.
 Rev. ed. of work originally published: New York : Warner Books, 1999.
 Includes index.
 ISBN 978-1-60061-102-5 (pbk. : alk. paper)
 1. Drawing--Technique. 2. Drawing, Psychology of. 3. Creation (Literary, artistic, etc.) I. Meglin, Diane. II. Title.
NC730.M3783 2008
741.201'9--dc22
 2007047828

Illustration credits:

Allen, Thomas B.: 124
Bishop, Isabel: 60
Cézanne, Paul: 229
Cober, Alan E.: 78-79, 204, 206, 209, 218
Corot, Jean-Baptiste: 168
Degas, Edgar: 37, 40, 142
Fantin-Latour: 227
Feelings, Tom: 127
Frankenberg, Robert: 92, 105
Frazetta, Frank: 29, 50
Gerberg, Mort: 160, 198
Gersten, Gerry: 117
Gogh, Vincent van: 19
Gold, Albert: 62
Gundelfinger, John: 94, 185, 190, 196, 202
Hamill, Pete: 27, 64, 74--75
Holland, Brad: 20-21, 22--23, 24, 133, 136, 223
Kossin, Sanford: 43, 56
Laurencin, Marie: 224
Levine, David: 16–17
McMahon, Franklin: 154, 156
Meglin, Diane E.: 41
Meglin, Nick: 14, 25, 26, 31, 45, 47, 57, 59, 66, 106, 107, 121, 128, 129, 130, 131, 140, 145, 146, 147, 148, 158, 165, 177, 180, 189, 211, 212, 237
Michelangelo: 53
Morandi, Giorgio: 102, 103, 170
Negron, William: 10, 13, 72, 73, 175, 177, 184, 192, 201, 225
Papin, Joseph: 81
Payne, C.F.: 32, 77, 84, 85, 86, 87, 88, 91, 122
Pinkney, Jerry: 58
Pissarro, Camille: 233
Podwal, Mark: 68, 76, 80, 89, 152
Punchatz, Donald: 12, 61, 100
Rembrandt: 18, 55, 97, 143, 144, 183
Rodin: 54, 231
Sacks, Shelly: 67, 96, 110, 112, 113, 114, 115, 150, 164, 187, 188, 235
Saris, Anthony: 172--173
Schwartz, Daniel Bennett: 48, 104, 134, 157, 210
Seurat, Georges: 186
Shamey, Tim: 70, 116, 220
Smith, Joan Gillman: 52
Smith, William A.: 34, 36, 63, 98, 99, 182, 217
Sofo, Frank: 162, 213, 214, 215, 238, 239
Tinkelman, Murray: 38, 39, 118, 119, 120, 159
Topolski, Feliks: 178
Torres, Angelo: 108, 166, 195
Toulouse-Lautrec: 138
Tulka, Rick: 82, 83, 90, 194

All uncredited art reproduced from the sketchbooks of the author.

"Diane, how about we add Benjamin to our 'Max and Elena' dedication"

"I couldn't agree with you more, Dad!"

N.M. & D.E.M.

Acknowledgments

The authors would like to acknowledge Bruce Korn for his time, energy, and expertise with function keys and other key functions.

Linda Maloof for her positive energy, generous nature, and beautiful smile.

Amye Dyer for making this book happen, Jessica Papin for picking up the pieces and making them all fit together so beautifully, and Vanessa Lyman for helping to make it happen again.

Sharon DiGiulio for her talent, energy, and encouragement of art and artists.

Charlie Kochman for his ongoing support and being a man of his Word.

Dr. Mel Fishman for his passion for clarity and reverence for words and their true meanings.

LLL for her labor on computers and collaborators.

Chris, the best teacher, friend, brother and son that anyone could ask for.

To the artists of the past, present, and future, to whom this book was written for and about.

And most especially:

Thomas B. Allen	Brad Holland	Anthony Saris
Alan E. Cober	Sanford Kossin	Daniel Bennett Schwartz
Tom Feelings	David Levine	Tim Shamey
Robert Frakenberg	Franklin McMahon	William A. Smith
Frank Frazetta	William Negron	Frank Sofo
Mort Gerberg	Joseph Papin	Murray Tinkelman
Gerry Gersten	C.F. Payne	Feliks Topolski
Joan Gillman Smith	Jerry Pinkney	Angelo Torres
Albert Gold	Mark Podwal	Rick Tulka
John Gundelfinger	Donald Punchatz	
Pete Hamill	Shelly Sacks	

Preface

Welcome! *Drawing From Within* is open to amateur artists, professional artists, wannabe artists and don't wannabe artists. Students and teachers. Young and old. Talented people and . . .

HOLD IT RIGHT THERE!

Admit it, you were willing to concede that there are "untalented" people in the world, right? Sorry, but you're very wrong. Talent is *subjective,* and like all subjectivity, remains *relative,* not *factual.* Talent for drawing, music, writing, cooking, or bungee jumping cannot be measured by scientific standards.

What *can* be measured is personal satisfaction. How we feel. *Fun.* And that's what drawing (music, writing, cooking, bungee jumping, etc.) should be all about. It certainly is what this book is about.

Drawing can be a deeply satisfying, personal experience if we let it be just that. We often bring to this experience so many *outside* considerations that, unfortunately, the pure, simple pleasure of self-expression becomes muddled and complex. We make the mistake of looking *outside* ourselves for validation of what is, in fact, an *inner* experience. We look to others for approval, for them to tell us how good our work is before we can feel good about having done it! In other words: We draw for *others.*

Drawing from within is a process by which we can combat these pressures, accomplish our goals, and maximize our creativity. This approach will be explored in the following chapters. You will have an opportunity to experience the process and discover how it can be manifested in your own self-expression, be it with drawing, music, writing, cooking, or bungee jumping!

Contents

7 Preface

11 By Way of Introduction

15 CHAPTER 1

Materials Are Immaterial
The Media Isn't the Message

33 CHAPTER 2

Different Strokes for Diffident Folks
The Goal is the Whole and Not Just Some of the Parts

49 CHAPTER 3

A Word to the Whys
Brainy Days Can Get You Down

69 CHAPTER 4

Being Aware of the Where
It Kinda Makes You Wander

93 CHAPTER 5

Turning on the 100-WHAT Bulb
Subjects to Your Approval

109 CHAPTER 6

Critical Condition
The Smell of Success Isn't Worth a Scent

123 CHAPTER 7

Sketchbook *Sí*, Camera *No*!
It's a Pad, Pad World Out There

137 | CHAPTER 8

Believing Isn't Seeing
Perception Can Be Deception

153 | CHAPTER 9

There's No Time Like the Pleasant
Clocks Need Two Hands, Artists Only Need One

167 | CHAPTER 10

For Better or Versus
The AND Justifies the Means

179 | CHAPTER 11

Imitation Ain't Inspiration
Visitation Rights and Wrongs

190 | CHAPTER 12

Learning Is a Churning Experience
There Are No Runs and No Hits Without Errors

205 | CHAPTER 13

A Drawing Exorcise
Comes the Evolution

219 | CHAPTER 14

A Flick of the Risk
Getting Careless? Wonderful! Have a Ball!

236 | Afterword

238 | Index

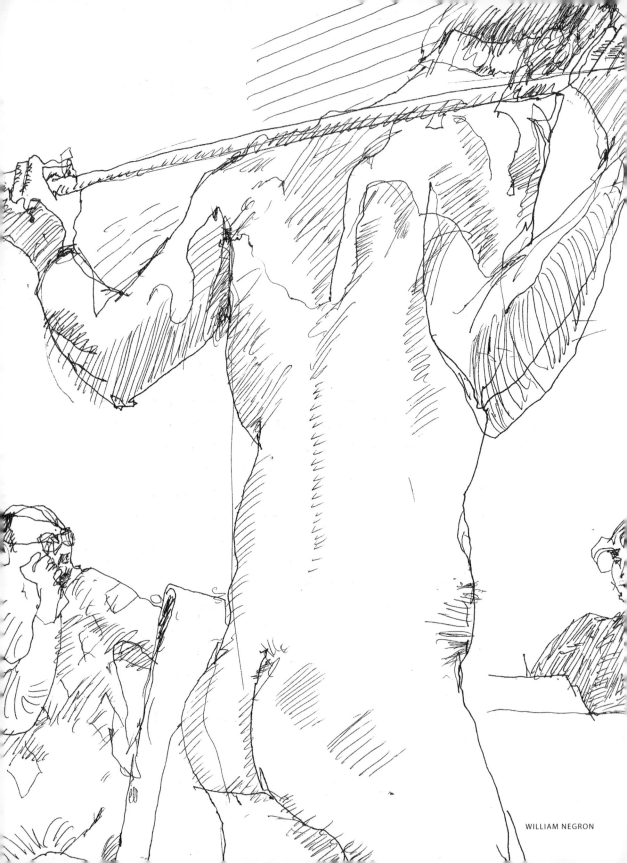

WILLIAM NEGRON

By Way of Introduction

No one can teach you to draw. Where art education often fails is in the premise that drawing can be taught. It can't. Then how does one learn to draw? One doesn't! One draws! The education of an artist is the result of his or her experiences of drawing.

Many of us come to drawing through traditional educational approaches. I taught drawing and illustration at the School of Visual Arts in New York City for over ten years. As any of my students would tell you, my methods were anything but traditional. During the very first class I would say, "I cannot teach any of you to draw. What's more, neither can any other instructor in any school. Nor can any book on the subject teach you how to draw. It isn't possible to teach anyone how to draw. Drawing is self-taught."

This greeting was never received with wild enthusiasm. Students had just committed time and money for a full semester of art instruction. But truth is truth, and I would rather deal with their disappointment at the start than promise them something I know no instructor could deliver. After my first semester of teaching, I realized that truth serves as the best foundation upon which solid trust can be built.

Learning anything is an experiential process. Children learn to walk and talk through experience, not from a book and not from an "Intro to Walk and Talk" class. Learning to draw is a similar natural response. People learn to draw through the experience of drawing. So, my major responsibility was to free students from all of the ubiquitous "how to" considerations. Once I accomplished that, the results were astonishing—my students were not only pleased with their work, they had fun doing it. And, more outrageously, they give me credit for their accomplishments!

Over the years, I've heard many tales from bewildered and confused art students. Some had learned formulaic approaches to drawing like, "Draw the figure seven-and-one-half heads high," or "Start all figure drawing with ovals." Others were taught the "un-learning" method from instructors who assumed that they had been taught incorrectly by other instructors! They recommended reprogramming by an expert (like themselves, of course) and that their students needed to rid their minds of all of those *former* educational blunders.

Drawing From Within is definitely not more of the same. Whatever art education you've had, whether it was formal (art school), informal (private lessons), casual (life-drawing sessions), or the self-taught variety (art-instruction books and "how-to" magazines), it has been valuable only if it took you to the place where your real education took place: *your drawing surface*. Even if you haven't picked up a pencil since kindergarten, the greatest factor in your progress has been, is now, and always will be, your drawing experience. Not facts, techniques, or anything else you've committed to memory. The act of drawing

DONALD PUNCHATZ

is what makes you an artist, not how much information your brain has stored! It isn't your memory that needs to be tapped. Instead, it's that bottomless keg of individuality we call "talent" that needs tapping. And the most effective taps for the job are *drawing assignments*. If mere mention of the word "assignments" pushes the old "homework" button, fight the negative reservations—assignments are your friends! Especially these assignments. Keep this in mind:

ASSIGNMENTS AREN'T PUNISHMENT. They should be fun. By avoiding assignments you deny yourself the learning experience and that would be a punishment!

ASSIGNMENTS AREN'T TESTS. Their purpose isn't to "show what you know." Just the opposite—these assignments will help show you what you don't know.

ASSIGNMENTS AREN'T COMPETITIVE. It's not you versus anyone. There always has been and always will be room for anyone with a personal statement. If you begin a drawing with the spirit of competition (as if it were you as *artist* versus your *subject*) you're gonna lose! The score? Six–love, six–love, six–love, love! And the game results will never change.

Your drawing of a tree will never be so "real" that birds will nest in it, nor will its leaves magically turn color in the fall.

These assignments will require nothing more than your own individual artistic response. Each will provide you with a new adventure, filled with new problems that require new solutions and the excitement of discovery through your own personal experience. Remember, drawing is about expression and not photographic replication.

Drawing From Within will create a context in which real learning can take place through self-education. There are no methods, no procedures, no formulas to memorize, no philosophies to accept, no magical techniques to apply. And since there are no beliefs to dedicate yourself to, you are free to dedicate yourself to the only approach that truly works—the work itself!

Materials Are Immaterial

The Media Isn't the Message

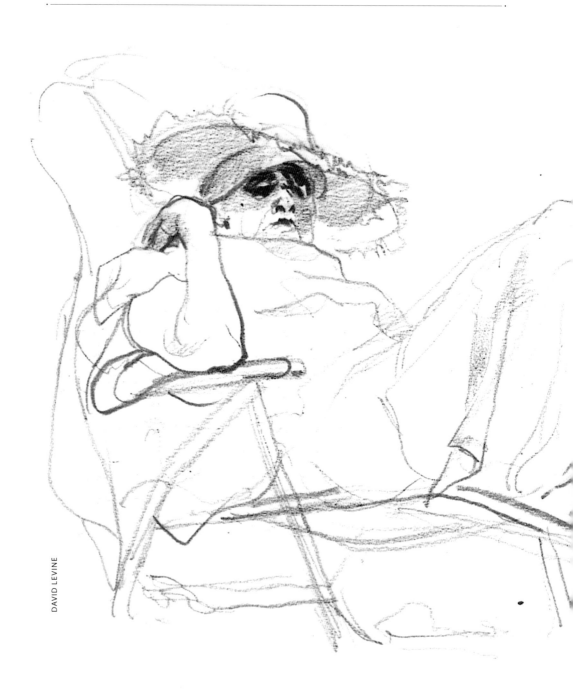

W

hen you are drawing from within, your chief concerns should be what and why rather than how a drawing is done. Therefore, you won't find much information in this book about media and materials. Here, a pencil is a pencil is a pencil, and 2B or not 2B isn't the question. Materials don't make drawings, artists do! Technique and rendering have little to do with making a personal statement.

During the initial stages of drawing, your concentration should be limited to what you see and feel and the act of expressing

yourself. When favorite materials (those that offer the most comfort and security) are relied upon, then the tools we use to express ourselves have become too important.

Media has always played a minor role in art. Let's use two famous Dutch artists, albeit of different eras, as examples. Rembrandt certainly knew his way around a palette, and his mastery of the brush cannot be denied. However, his use of these materials has never been the reason his work is held in such high regard. Van Gogh never displayed Rembrandt's mastery of drawing

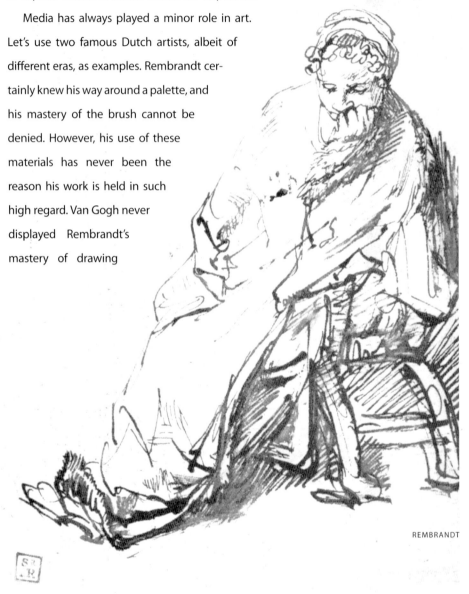

REMBRANDT

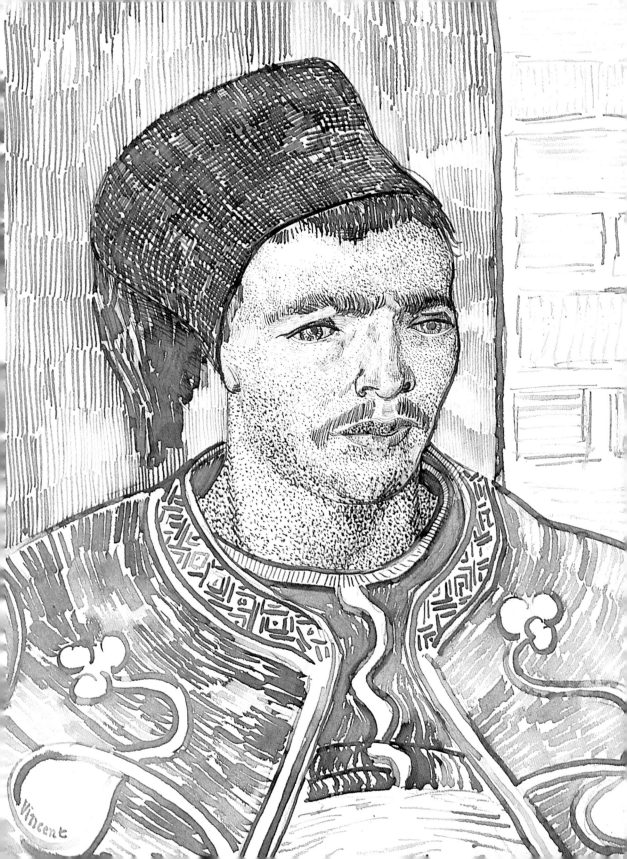

accuracy nor subtle coloration, but van Gogh's passion and intensity for his subjects made his work equally beloved. In the work of both of these artists, achievement has never been a matter of how.

Yet, whenever I said, "Materials are immaterial!" I drove my students bonkers. They were so accustomed to focusing on rendering that they had built their drawing foundations on it.

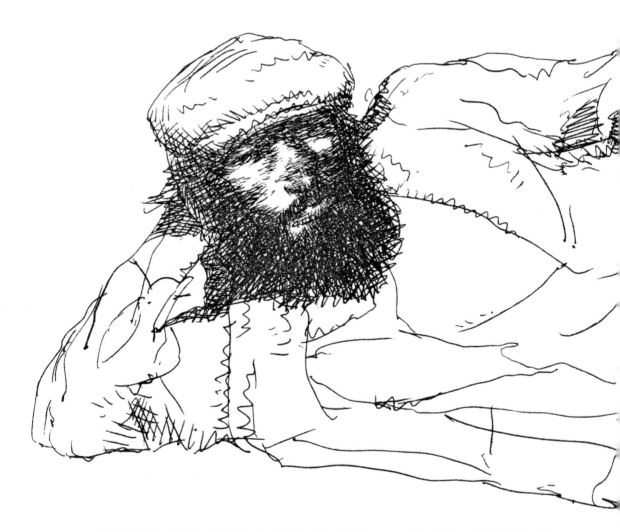

"If you use the very same tennis racket Pete Sampras or Venus Williams used, you too could win the U.S. Open or Wimbledon," I said to my class. They laughed. Obviously, this is absurd. Tennis champions will get the same result from any style or brand of tennis racket. Pete and Venus would play well using a snowshoe! In these cases it's obvious materials are immaterial.

BRAD HOLLAND

"Was it the bat or the batter that made Hank Aaron the home run champion?" I ask my students.

"The batter, of course!" they'd reply.

Then, I'd announce that all drawing exercises for the first few weeks (both those drawn from life in the classroom and those done on location) would be drawn directly with fountain pen. The students reacted as if I were a sadist whose greatest joy derived from making their lives miserable!

"Didn't we all just agree it was Hank Aaron and not his bat that hit 755 home runs?"

"Yes, but that's different!"

BRAD HOLLAND

"How is that different? Okay, another analogy! Clinical analysis
might very well prove it was a particular Remington typewriter that
set down Arthur Miller's rich, free-flowing dialogue for his most

cherished plays. Even if this fact led to a stampede of writers rushing to buy that same model typewriter, would it have changed the literary world one iota?"

My students moan begrudgingly. Nevertheless, they begin to get the idea that in any endeavor it is the person, not the material, that is responsible for the work.

So why the fountain pen? There are several reasons for inflicting this "writing" instrument on art students. The most important reason is that when you use a fountain pen, every line drawn on paper is a commitment. There are no erasers to destroy "mistakes" nor are there "bad lines," since drawing from within is, by definition, a non-

BRAD HOLLAND

judgmental approach. There is only drawn response to subject matter.

Please remember, the goal is not to make a pretty drawing, a neat drawing, a good drawing, etc., but just *to draw*. Therefore, every pen line set down is a bold, permanent expression of search and discovery, taste and tendency, question and conclusion. In a pure learning experience, in order to "correct" a drawing, one needs to *see* the original line and be able to indicate the "improvement" accordingly. With an eraser, that original line would disappear, and, with it, some of the learning potential for that work.

The fountain pen provides a wonderful, convenient, on-the-spot drawing instrument. Combine the fountain pen with a sketch pad and you'll have a portable studio. Wherever and whenever you find yourself with even a few minutes, you can react spontaneously to all the visual stimulation around you.

Unlike the ballpoint pen or roller-tipped markers, the flexible point of the fountain pen offers a line that responds to your individual touch. The amount of pressure you exert on your drawing surface will create a

NICK MEGLIN

thick and thin line of an extremely person-al nature. This results in differences similar to those of your individual handwriting. Anything that helps separate your work from another artist's is important in mak-ing your statement more personal.

When my instructions in class were still met with moans and groans, I would intro-duce the work of Frank Frazetta, a popular artist and a close friend. Frank, Angelo Tor-res, and I were part of a small group of young men who played ball and hung around together in Brooklyn. We shared drawing interests and occasionally attended life-drawing sketch classes at the Brooklyn Museum and the Art Students League.

PETE HAMILL

Frazetta had little formal art education, but he was a "natural" from the very start. Invariably, someone in our classroom would approach Frank during the break, look over his shoulder, and ask him about his drawing materials. Some of them actually attempted to buy his "miraculous media" with which he had captured the living form so beautifully and effortlessly. Frazetta never understood why anyone would want to buy his chewed-up pencil stubs!

"They don't even have erasers!" he said incredulously.

How absurd it was to think it was the drawing instrument and not the artist's hand behind it that was responsible for his remarkable drawings.

FRANK FRAZETTA

If my attempts failed to ease my students into accepting the fountain pen as a viable drawing instrument, my final statement on the subject always worked.

"You'll use the fountain pen because I'm the instructor and you're not!"

So much for being fair and reasonable!

As an artist, you must concern yourself with making personal statements. Respond visually to life around you. Interact with your subjects. These elements are what's necessary for you to produce meaningful work, not which materials you use.

Let's break down the most popular drawing media into three categories:

Pencil—this includes all shapes, grades, sizes, and properties, including graphite, charcoal, carbon, Conté crayon, pastel, etc.

Pen—any shape, size, and level of flexibility, including "dip-in," markers, and fountain pen varieties.

Brush—all shapes, sizes, and styles, including sable, camel, nylon, plus the many portable, cartridge-filled "brushes" available today.

So much for materials. Let's move on to what's really important. Your first . . .

ASSIGNMENT:
The Sky's the Limit if Supplies Are Limited

For this assignment, you will focus on becoming involved with your subject only. This will discourage your involvement with drawing materials per se. It will also allow you to experience your positive and negative responses to working with (and without) the comfort and security of materials you prefer or have already mastered.

1 Draw a person from life (not from a photograph).

2 Choose one drawing medium from each of the three categories listed previously.

3 Make three drawings of your subject using a different medium for each drawing.

EVAN GETS BRACES · JULY 18, 2002 11:56 am

C.F. PAYNE

Different Strokes for Diffident Folks

The Goal Is the Whole and Not
Just Some of the Parts

WILLIAM A. SMITH

34

A rt is the earliest form of visual communication and it hasn't changed all that much since the early cave drawings. Cavemen artists, however, weren't achievement-oriented. They felt the need to capture graphically their experience, and responded to that need. Plain and simple. Like their drawings—effective rather than affected.

Not so today. In our society we have become so achievement-oriented that we measure our efforts by results rather than by our own feelings of satisfaction. We have been encouraged to succeed through imitation rather than expand upon the individuality we naturally possess.

Drawing has always been the basic form of an artist's aesthetic response (the expression of thoughts and feelings in their purest, and, therefore, most effective sense). All too often, however, artists interfere with that natural response and become concerned with outside considerations, especially the desire to achieve. This misdirected path usually leads to compromise, imitation, and contrivance and, ironically, actually prevents true artistic "achievement."

Charles Schulz, one of our most beloved cartoonists, has written many profound "Peanuts" strips over the years. One of my favorites addresses the issue of achievement/goal with typical Schulz humor and insight. Schroeder, at the piano as usual, declares his intention to learn all of Beethoven's sonatas.

WILLIAM A. SMITH

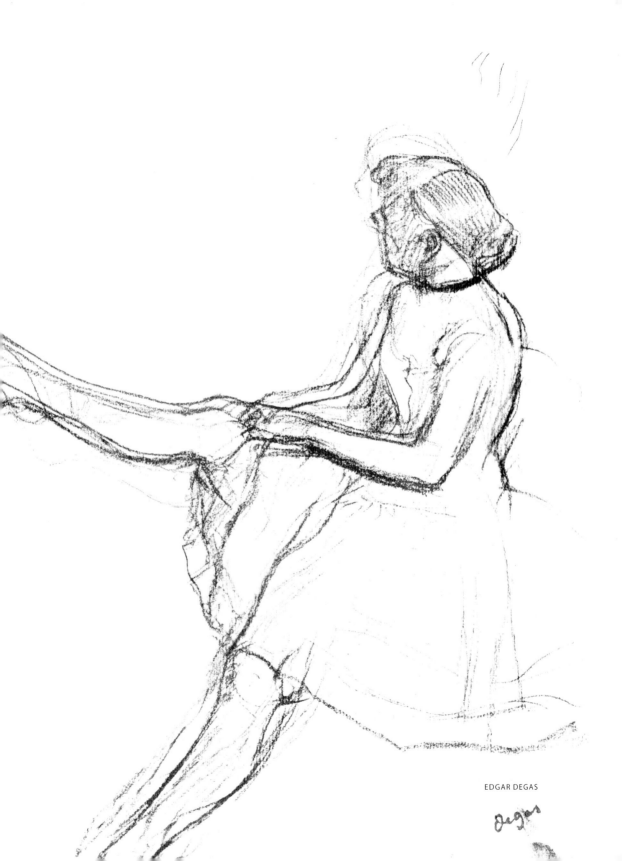

EDGAR DEGAS

Degas

MURRAY TINKELMAN

Lucy asks what he'll win if he actually accomplishes this goal. When Linus replies that he won't win anything, she walks off declaring, "What's the sense in doing something if you don't win a prize?" Lucy, I'm afraid, is like many of us who measure achievement by reward rather than *personal satisfaction*.

Satisfaction in any art form doesn't come from achieving perfection, since perfection doesn't exist in art. Satisfaction can be found instead in the experience of aspiring to an internal form of perfection that's measured in "fun" and not some *external* measure, i.e., "Best of Show."

MURRAY TINKELMAN

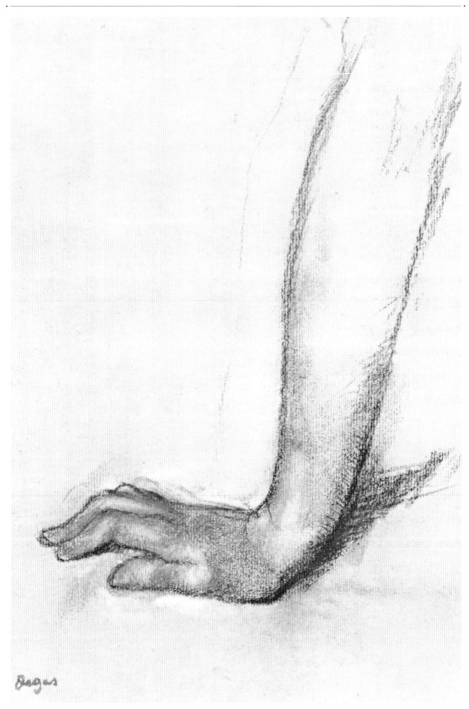

Degas

EDGAR DEGAS

Perhaps what kept those cavemen artists focused was that there were no "Best of Show" award ribbons to strive for. Art shows and exhibitions are wonderful when they remain pure-ly creative show-cases and maintain their museum or gallery atmosphere. It is only when a show is "judged" that a com-petitive context negates the positive aspect of art on display. What does "Best of Show" really mean? A sports competition makes sense because of quan-titative feedback—the First Place medal goes to the fast-est runner. Should the First Place medal in an art show go to the fastest painter? Can art be measured accurately as "First Place" or "Best of Show"? No way! A "judge" is a falsely elevated position, folks. As for the medals

DIANE MEGLIN

they bestow, all that glitters isn't gold. Judges only know what *they* like, not what is "better" or "best." Obviously, art judgment is a subjective/personal determination.

Personally, I would be in favor of only one competitive prize category:

"The winner of the First Place medal for Having Most Fun While Drawing is . . ."

To me, *fun* is what the education of an artist should be all about. And *judgment* should have no place in art whatsoever. It's important that everyone understands the difference between judgment and criticism. Since no crime has been committed, the former serves no purpose. But since "mistakes" are being made, the latter, when administered objectively, can serve a very useful purpose.

Constructive criticism is a process that allows us to build on the skills we have now toward a more satisfying future result. But it's not a one-way street. An exchange is necessary for criticism to be effective. Otherwise, it presents risks:

The *receiver* may view the criticism as an attack rather than an objective appraisal that could help make him more aware of something (if he doesn't become defensive).

And the *sender* may not be conscious of his or her own limited verbal skills in communicating that objective appraisal appropriately. Perhaps the sender is unintentionally (or intentionally) harsh or cruel.

One of the worst horror stories I've heard was from a student whose former instructor had looked at his drawing assignment

and said, "Do you have a fallback plan in case you don't make it as an artist?"

Great way to instill confidence, right? Yeah, sure! Fortunately, the student knew his instructor's reputation of being arrogant and opinionated. The lack of talent evident here was not displayed by the student! As if an instructor could determine who will or won't make it as an artist—or anything else! The role of

SANFORD KOSSIN

an instructor is to offer support through education so that each student can more fully realize his or her personal abilities and ambitions. A wise teacher wouldn't sit in judgment and offer opinions as if they were facts!

When students ask me to "correct" their work, I generally refuse.

"Your correction is more valuable than mine. I'd only be altering your work to fit my perception. Look at the model. Do you see that the hand in your drawing is larger in relationship to the head than the model's? Place the heel of your hand on your chin. Now extend your fingers to your forehead. Generally, the longest finger reaches somewhere in the middle between your brow and hairline. Having experienced that, now forget it! It's not a solution, and it's not a 'rule of thumb' (pun intended!). By observing nuances such as these, you'll be more aware of the 'norm' so that your own 'distortions' will be the result of conscious choice."

Suggestions such as these can help to guide students to search for solutions through their own observations. Lessons like these, in my opinion—not fact—are certainly more effective than an instructor's "corrections."

Drawing should be an effortless activity, a matter of aspiration over perspiration. But any casual approach often creates difficulties for those who prefer to do battle, to lock horns and meet challenges head-on with fists clenched and jaws set in determination. Why bother? We have only to get out of our own way to derive the ultimate drawing reward—satisfaction. It is a peaceful, benign experience . . . if we allow it to be just that!

Devoid of methods and procedures, drawing from within can provide you with personal satisfaction and the freedom to draw for the sheer pleasure of it, which is, in the final analysis, everything an artist can hope to attain.

Setting attainable goals doesn't translate into compromising or lowering standards. Goals should be measured in terms of satisfaction, not achievement. The final outcome of most endeavors has more to do with timing and luck. It serves our interests best if we're adequately prepared with the one important ingredient in the stew we can control, our natural response. If your goal is satisfaction in art, you can achieve it easily. Draw, don't make drawings! All it takes is a sincere, personal approach.

Think about that, but not for too long! Instead, start on the next . . .

ASSIGNMENT:

Let's Give the Artist a Hand

Many artists agree that the hand is the most difficult part of the human anatomy to draw. They also agree that after facial expression, hands tell us more about action and mood than anything else. Obviously, hands are important for artists to draw. And just as obvious is that you learn about drawing hands by drawing hands. So guess what you'll be doing? Right!

1 Fill three complete sheets in your drawing pad with drawings of your hands (or anyone else's that are available).

2 Promise yourself that you will continue to fill countless pages with subsequent drawings of hands throughout the rest of your life.

3 Keep that promise!

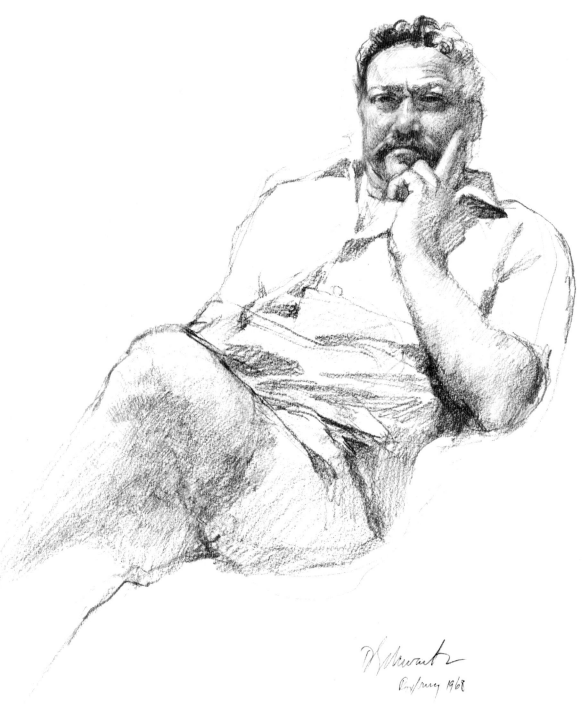

DANIEL BENNETT SCHWARTZ

A Word to the Whys

Brainy Days Can Get You Down

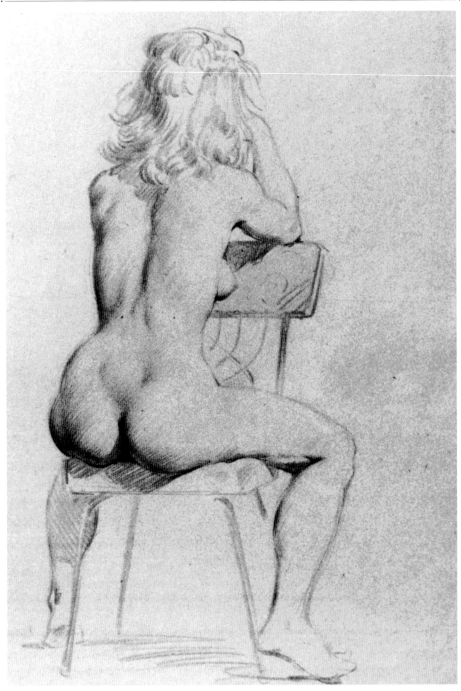

FRANK FRAZETTA

D rawing is a natural response to an artist's indi-
vidual experience, just as keeping a diary is a natural response for
a writer. This response evolves from a highly personal and com-
plex network of factors, which can be described as a combination
of what we see, what we feel, and what we think.

At the start, what we see plays the most important role. The
image is there. We have only to respond to it graphically.

What we feel is extremely complicated. We have no easy access
to that part of the brain, which houses our vast emotional spec-
trum. Nor do we have easy access to the heart, despite all the love
songs. We feel what we feel, and that's about the whole story.

JOAN GILLMAN SMITH

As for what we think, a clinical approach restricts the mind to where it is focused at that particular time. We run the risk of trying to be clever as opposed to establishing a natural and spontaneous interaction with our subject. Or, if we have recently admired the work of another artist, we may become momentarily overinfluenced and our own work may become derivative and show signs of *imitation* rather than *inspiration*. We'll talk more about that later.

So, artists need to "*draw* it out," not "*think* it out."

Why we draw is simply to enjoy the act of drawing. And we can achieve this enjoyment only if we stop trying so hard and allow our natural response to surface.

Young children are very clear about this subject. They don't need a reason for drawing. They do it because they want to. Their drawings are spontaneous and refreshing because their egos aren't involved. They draw for themselves and not for the museum wall. If they seek approval for their work, it's an afterthought and not their motivating factor. We would all be better

MICHELANGELO

RODIN

REMBRANDT

served if we could retain that innocent approach, or if we were able to let our individual talent emerge naturally without questioning it, directing it, or restricting it with intellectual considerations.

"I find it unnatural to be natural," a student named Donna said during one of my classes. While her contradiction made me smile, she made a serious point. Up to that moment she had been totally involved in the usual game of "art for others." Donna was a very bright girl and from early in her life her parents had encouraged her to pursue a career in medicine. Her long-standing love of drawing and painting were seen as "threats" to her academic career and were thus discouraged. Donna's parents, albeit well-intentioned, thought her time and energy would be better spent on academic studies. Sound familiar?

Donna's art had become a proving ground, rather than an activity she enjoyed for the sheer pleasure it brought her. She tended to imitate the work of successful favorites in order to prove her worth as an artist to relatives and friends, as if their

approval could validate her talent. She had come to an evening class at art school to prove something.

By the end of the semester Donna learned that it is better for our personal approach that we adhere to the basics: view life around us through our own eyes and respond in kind, thereby limiting conscious influences. We cannot limit unconscious influences nor can we erase them from our experience. What we have loaded into our mind's computer will be there forever. But we can also learn to cease making demands on ourselves and reclaim some of that fun we had drawing before adult intellect got in the way.

On location for an on-the-spot drawing class assignment, Donna sketched several

SANFORD KOSSIN

JERRY PINKNEY

geologists and their discoveries during an archaeological dig near her home. Some of her drawings were seen by a writer covering the story for a local newspaper, and he used them to illustrate the article.

Several years later, a note of thanks was delivered to me at my School of Visual Arts classroom. Donna had been hired as an artist by a natural history museum. She worked on various projects for the museum's graphic needs. Hopefully, Donna's parents were satisfied with her success in the "science world." But, to me, what will always be most important is the personal satisfaction Donna derives from her art.

Artists and scientists are alike in some ways, yet so very, very different in others. Scientists seek objective, logical, and predictable responses. Artists seek subjective, free-wheeling, unpredictable, and original responses. In optometry, for instance, the eye doctor uses specific eye charts to calculate a patient's vision parameters. This removes all subjectivity—the patient either sees the letter "Y" or doesn't. It is a "Y" for you and me alike and it is the only right

ISABEL BISHOP

answer. If a person persists in their belief that the "Y" is an "A" and the chart is wrong, there's nothing we can do except avoid them on the highway!

DONALD PUNCHATZ

ALBERT GOLD

While psychotherapy is most assuredly considered science more than art, the two fields overlap in certain projective psychological testing. A patient might be asked to complete a Rorschach test, for example. Here, the therapist displays abstract shapes and asks the patient to

WILLIAM A. SMITH

describe what he sees. We all see different "pictures" in the Rorschach images, so there are no "right" or "wrong" answers. The individual interpretation of the abstract shapes helps the therapist to understand personality differences and the subjective approach alone prevails. We all discern images and shapes uniquely. One man's butterfly is another man's guillotine. To each his own.

The same holds true with a popular test that requires a patient to draw a tree. The varied visual responses, including those indicated or omitted, factor into the interpretation. In art, the same subjective imagery prevails. Were El Greco's seemingly overlong figures the result of astigmatic vision? Or did he "see" that way because it was his personal vision? Who cares? Either way, we can enjoy the uniqueness of El Greco's work.

It's easy to see personal vision at work in an art classroom. For example, one of my favorite classroom models was Ben, who was six feet tall and weighed about 170 pounds. I appreciated Ben's special ability to strike and hold three-minute action poses. Of course, his height, weight, and body structure remained constant for all twenty students. But you'd never know it when the drawings of Ben were pinned up for the nightly discussion. Renditions

of Ben gave him a frame that varied from 110 pounds to 230, from five feet four inches to Shaquille O'Neal. Some students sketched his body as if he were cadaverous! Others depicted him as a half-human, half-serpentine alien from a science-fiction thriller. So much for objectivity!

Twenty students, twenty drawings. No two alike. Quite amazing. And, most important, neither "right" nor "wrong." As an art instructor, I am dedicated to helping all my students free themselves from the bonds of preconception, negative self-judgment, and restricted expression. So, twenty different drawings? I couldn't ask for anything more.

It's time for you to stop thinking about everything you've just read and start drawing your next . . .

W,

ASSIGNMENT:
It Shouldn't Gray Matter at All

Drawing From Within attempts only to *limit* thought in the first stages of artistic response. The key here is to draw it out, not think it out. Where we run into trouble as artists is when we let our logical, rational minds dictate our art.

1 Pick up an apple. Look at it. Feel its smooth surface. Observe its shape and markings. Smell it. Finally, place it in front of you and draw it.

2 Pick up the apple again. This time, take a few bites out of it. Listen to the crunchy sound as you bite into it. Let the juice flow onto your tongue. Be aware of the texture and the flavor as you chew and swallow.

3 Now draw the apple core (or whatever remains).

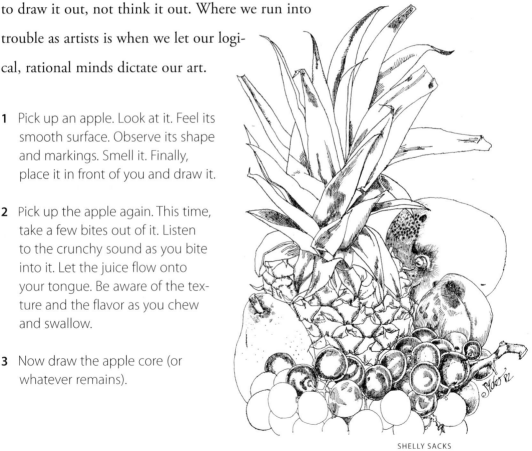

SHELLY SACKS

MARK PODWAL

Being Aware of the Where

It Kinda Makes You Wander

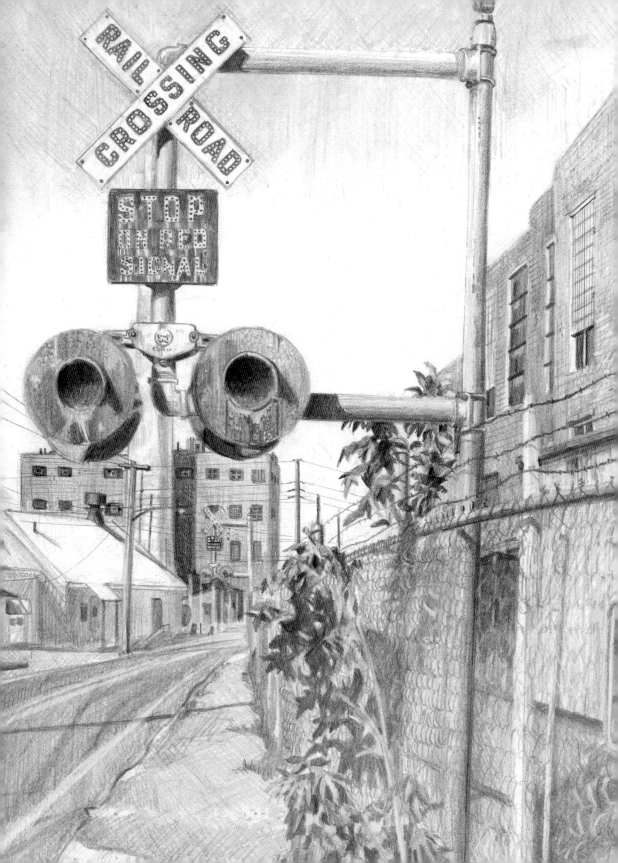

Spontaneity in art requires that the artist respond to the moment whenever and wherever it occurs. We live in the present, so our drawing response should reflect the moment. A practiced, well-rehearsed solution to a drawing problem is the antithesis of responsive drawing. Nothing learned or, worse, the imitative process, even if it is self-imitative, will contribute to an artist's growth. What can contribute, however, is what the artist can do to enhance the *where*.

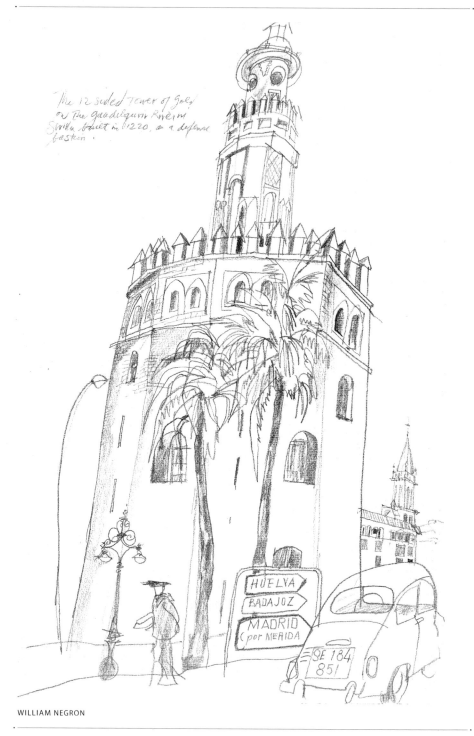

The 12 sided Tower of Gold on the Guadalquivir River in Seville built in 1220, as a defense bastion.

HUELVA
BADAJOZ
MADRID
por MERIDA

SE 184
851

WILLIAM NEGRON

Sound, for instance, plays an important role in our moods and energy level. Music prompts one emotional reaction, radio talk shows another, sporting events yet another. The same is true for lighting. A natural setting elicits one response, dramatic lighting offers a different one, etc.

Art isn't an energy that is released when the artist is producing art and then ceases to exist when the work is done. It is a constant force in an artist's total experience; it permeates our very

WILLIAM NEGRON

Rota, Spain

existence. We, as artists, cannot observe anything without an image forming and filling a chamber of our mind, whether consciously (with hope that it can be accessed at a later time) or, unconsciously, to emerge as a "new" concept in the uncontrollable, unpredictable process we call *creativity*.

Therein lies the true nature of our personal response. There is indeed nothing new on the planet, only what has been restated with an individual, unfamiliar spin.

Many students are reluctant to draw in situations away from the privacy and luxury of their controlled studio environment.

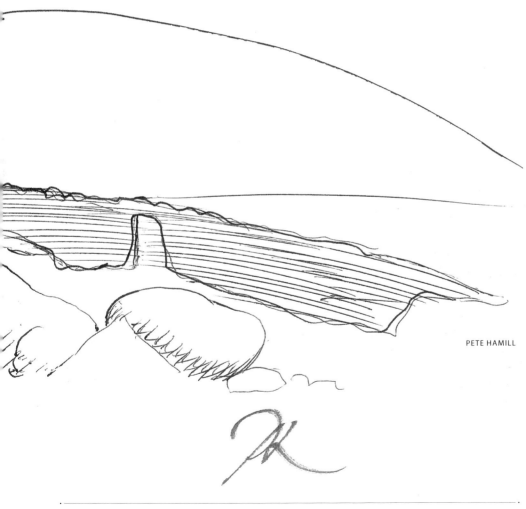

PETE HAMILL

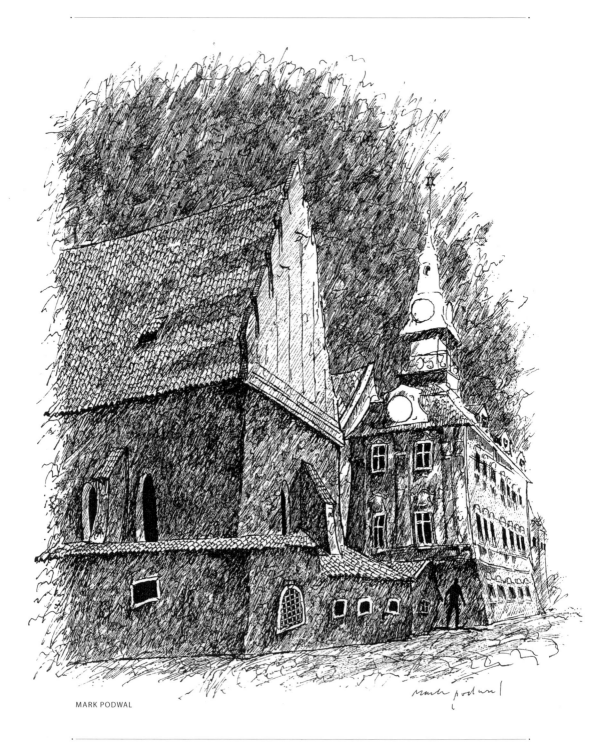

MARK PODWAL

C.F. PAYNE

When my on-the-spot assignments forced them into these draw-ing "trenches," many claimed it was tantamount to "cruel and in-humane punishment." But, eventually, even those who were most reluctant initially would express positive feelings about their expe-riences later. By the end of their semester, many continued to carry sketchbooks with them so they could always enjoy the experience of responding to the moment.

There is something truly invigorating about the challenge of capturing a subject's essence in a "one-shot-at-it-only" situation. Courtroom artists, for example, develop their skills in this manner. After working professionally for a while, however, the pressure

ALAN E. COBER

of having to produce drawings usable for nightly television or the next morning's newspapers can take its toll on the artist's sheer pleasure of drawing. To counter that, one courtroom artist, Joseph Papin, carried a sketchbook with him in nonprofessional situations: in subways, in coffee shops, on street corners, to "reinstate the fun" of sketching on a personal level. He found, interestingly, that these drawings helped "sharpen" his professional work in the process.

I met with author/journalist/editor Pete Hamill many years after we were students together at the School of Visual Arts. We were astonished by how our lives had paralleled in so many ways: both wanna-be illustrators who primarily became writers instead. We had a great laugh when we realized that not only did we both still carry sketchbooks (along with our writing pads), but that in our individual cache of writing and drawing tools we also carried the same inexpensive Esterbrook fountain pens we had used in our art school days. As "writers who draw" we were always ready for an *on-the-spot* experience.

MARK PODWAL

JOSEPH PAPIN

During an interview he was conducting with filmmaker Federi-
co Fellini, film critic Giovanni Grazzini was curious about the "one
hundred and twenty-nine ballpoint pens, twenty-one pencils, and
eighteen felt pens" he counted on the famous director's desk. As

a youth in the Allied-occupied Rome of World War II, Fellini helped to support his family by doing caricatures of U.S. Army soldiers. Fellini always considered himself a "visual artist" regardless of the medium he worked in. Films such as *La Strada*, *La Dolce Vita*, *8 ½*, *Amarcord*, etc., attest to the significance of imagery in his work.

Fellini said, "Some people get a quick handle on things by means of words, by sensations. I design. I sketch the traits of a face, the details of a costume, a person's attitudes, expressions, anatomy. That is my way of getting close to a film I'm making, of understanding what it is and beginning to look at it in the

RICK TULKA

RICK TULKA

eye. Later on, these sketches, these shortened notes, end up in the hands of my collaborators. The scene designer, the costumer, the makeup man use them as models in preparing their work. That way they too begin to familiarize themselves with the mood of the story, with its nature, its connotations. Thus the film takes on a sense of anticipation, each sketch providing something to speculate about."

If true for professional artists, writers, and filmmakers, it should come as no surprise that I expect *art students* to carry a sketchbook

C.F. PAYNE

HIPPING/CAMPDEN · SEPT·8·2006

C.F. PAYNE

with them everywhere too, if for no other reason than to experi-
ence the cause and effect that is so important to responsive draw-
ing: the artist's graphic reaction to visual stimulation. The creation
of all art forms is an evolving process. It is this ever-changing dy-
namic that emerges as the one constant. Throughout history art-
ists have described creation as a learning stage about which they
remain students for life.

Stephen Sondheim is another original talent worth discuss-
ing at this juncture. He has written the scores for many musi-

cals that have expanded that genre's horizon further than any other composer/lyricist in modern theater history. Perhaps what defines Sondheim's remarkable work most of all is his desire to address and ability to discern individual perception, emotion, and concept—again, what we see, what we feel, and what we think. Songs like "I Remember Sky" (*Evening Primrose*), "Sorry-Grateful" (*Company*), and "Someone in a Tree" (*Pacific Overtures*) take the listener on a journey to thoughtful, emotional places seldom traveled in traditional Broadway venues.

Perhaps the Sondheim song that relates to creativity best is "Finishing the Hat" from *Sunday in the Park with George*, a musical with Impressionist painter Georges Seurat as its subject.

C.F. PAYNE

C.F. PAYNE

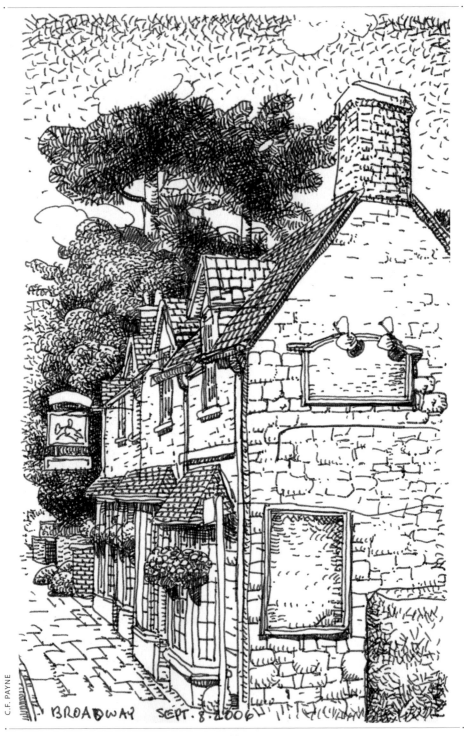

BROADWAY SEPT. 8. 2006

C.F. PAYNE

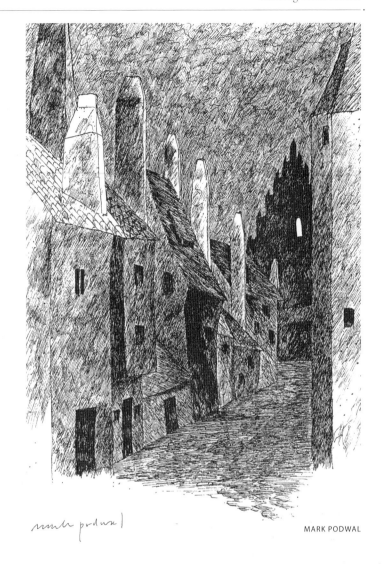

MARK PODWAL

The lyric speaks of Seurat's dedication, sacrifice, and unwilling-
ness to compromise in his art. It also serves as both a personal and
universal statement of the joy and satisfaction of creativity. The

RICK TULKA

ending to the complex, emotional musical discourse is most tell-ing in its simplicity . . .

Look, I made a hat
Where there never was a hat.

My hope is that your sketchbook will reveal as much about yourself for your-self. You can ensure that by completing the next . . .

ASSIGNMENT:
Location, Location, Location

Don't wait until you're in a gondola in Venice or
watching a sunset on the Maine coast to be inspired.
How about a locale a little closer and a lot more per-
sonal, like somewhere in your daily life?

1 Make an on-the-spot drawing of an
exterior scene from a vantage point
viewed in your everyday environment.

2 Make an on-the-spot drawing of an
interior scene from a vantage point
viewed in your everyday environment.

3 When you've completed all the
assignments in this book, go back to
both vantage points and draw those
two locations *again*.

C.F. PAYNE

ROBERT FRANKENBERG

Turning on the 100-WHAT Bulb

Subjects to Your Approval

JOHN GUNDELFINGER

As an instructor I've never experienced a semester when at least one student isn't plagued by a case of the "what to draw blues." Despite the focus of my course, "Drawing From Within," some students feel they need to be told what to draw. Even in such a personal matter as "what is within" they depend on directions.

"Draw what you see" doesn't do it for them.

"What should I see?" is their sincere, bewildered question.

Since the premise of my curriculum addresses the artist's natural response, I don't dismiss these students as "lost causes." If even one person admits to being confused, there will invariably be others who are reluctant to admit their own lack of clarity.

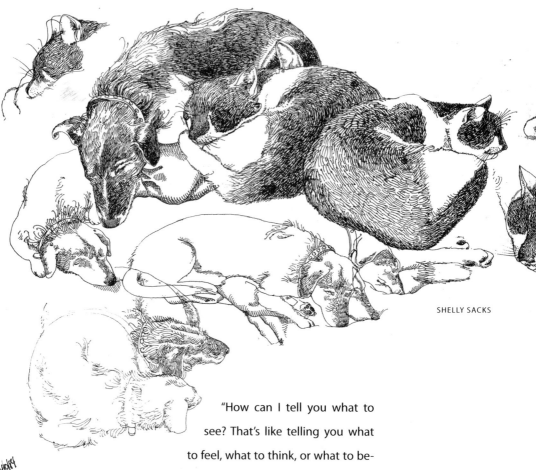

SHELLY SACKS

"How can I tell you what to see? That's like telling you what to feel, what to think, or what to believe." *Within* is an intensely *personal* experience.

"Draw something you feel like drawing. Don't think about it. You don't need a reason. Rodin defined 'artist' as 'The man who takes pleasure in his work.' We draw for pleasure, so choose something that gives you pleasure to draw. And certainly don't agonize over it. If you draw your cat because it's convenient—he's just lying there (busy being a cat)—that's reason enough."

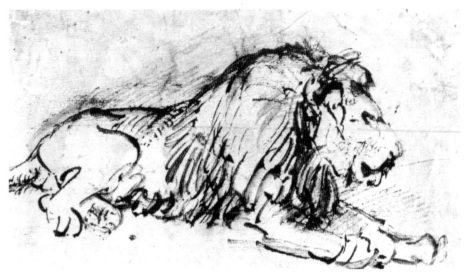

REMBRANDT

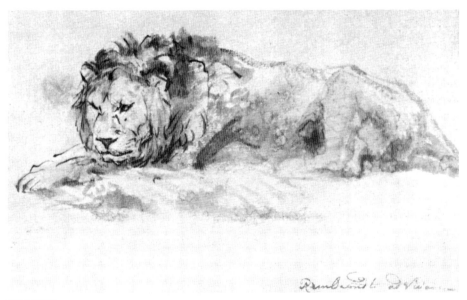

REMBRANDT

"What size should I draw my cat?"

"Whatever!"

"What medium should I use?"

"Whatever! Ultimately, the drawing instrument becomes only the extension of the eye by way of the hand. The eye sees, the hand reacts, the instrument delivers the message to the drawing surface. It should be a brainless process. Simply draw the cat as he

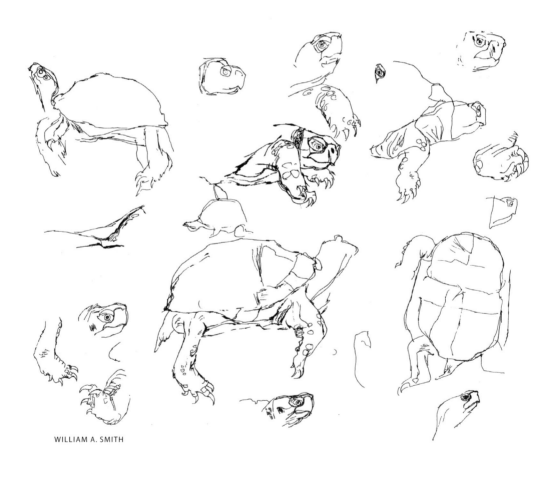

WILLIAM A. SMITH

WILLIAM A. SMITH

exists, alive and breathing. Don't make allowances for idealization or improvements on nature. And what is your secondary goal (the primary goal being to draw for fun) in doing this?" I ask.

"To make a drawing of my cat as he exists, alive and breathing, without making allowances for idealization or improvements on nature."

"Thank you. You're catching on!"

This approach will enable the artist to see and feel the

DONALD PUNCHATZ

difference between a real, living, breathing cat and a stuffed animal that has stereotypical features of a cat.

The human form populates our physical world and much of the world of art. What to draw can easily be responded to by whom to draw. Subjects are all around us: friends, family, and total strangers who, if you apply your best James Bond spy techniques, will remain oblivious of your *look/draw*, *look/draw* reconnaissance mission.

Drawing children has certain advantages over drawing adults. Children usually stay focused on whatever's directly in front of them. They seldom look up and don't pose as self-consciously as their adult counterparts. Nor are children concerned about presenting their most "flattering side."

When it comes to drawing inanimate objects, concentrate on what the object does. The function of the utensil determines its design. A drawing of what that utensil looks like should reflect that function. A "well-drawn" spoon, for instance, is one that looks like a handheld instrument capable of lifting a manageable portion of food from plate to mouth. A baby learns what a spoon is by experiencing its function. A mature mind can usually ascertain function by design and form alone, that is, the spoon's shape suggests its essential scoop capabilities as well as its ability to carry liquid or solid matter from one location to another.

What this boils down to is that if you want to draw what something looks like, draw what it does and the "likeness" will evolve.

But how exciting is it to draw inanimate objects? Once again, we've entered the land of subjectivity. Drawing "things" is as

exciting as it is to the artist drawing them, no more, no less. Giorgio Morandi, a noteworthy Italian artist, did countless drawings, etchings, and paintings of bottle arrangements throughout his life. When questioned about "sameness" he replied that every composition was different. When asked about "boredom" his answer was similar. He was enthusiastic about each new work and confident that he would never run out of variations of the same subject matter.

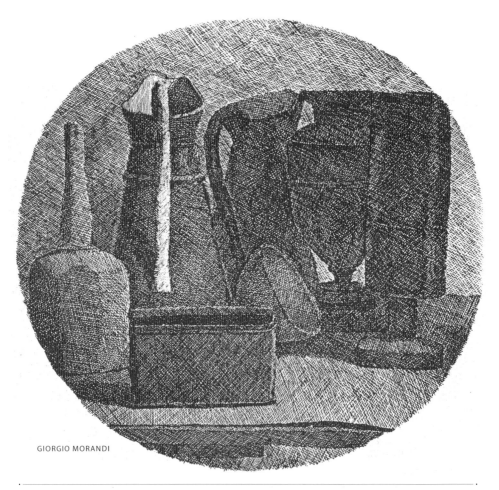

GIORGIO MORANDI

Ideas about what to draw are endless if every attempt begins with a personal response. There is no predictability to the human condition in terms of time, feeling, and the other complex variables that exist in the abstraction of our lives. The well runs dry only when we have nothing to say. That can't happen when you accept that while it's true that everything has already been said, it hasn't been said by you, at this moment in time, in this place, in this mood, with this lighting, etc.

GIORGIO MORANDI

DANIEL BENNETT SCHWARTZ

In literary circles, countless love stories can be linked to Shake-speare's *Romeo and Juliet*. But that didn't prevent each writer from spinning their own rendition. Each "version" brought a new, individual voice to the tale. You have only to watch *West Side Story* to see how exciting a unique approach to the *Romeo and Juliet* story line can be.

The more we are aware of our surroundings, the more we real-ize that drawing life around us provides countless opportunities

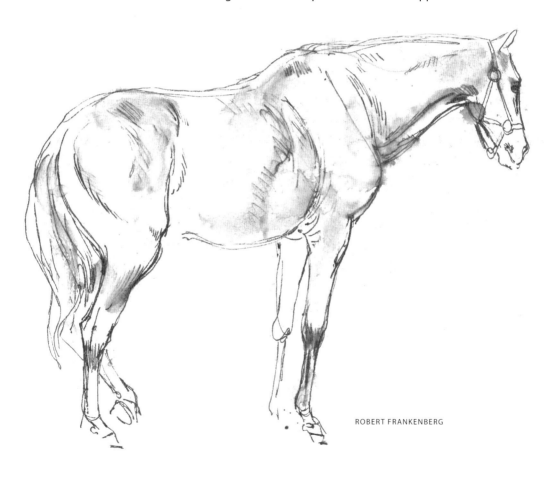

ROBERT FRANKENBERG

and possibilities to develop our own aesthetic response. The natural design of everything in our daily surroundings can be an exciting and fun-filled challenge. We are not bound by some oath that dictates our artistic response. We are neither cameras nor copy machines designed to duplicate only that which inhabits our lens. And to deny ourselves freedom from such restrictions serves little artistic purpose.

"What to draw?" That's obvious! Your next . . .

ASSIGNMENT:

It's Fundamental—Fun Isn't Mental

And now for the creature presentation!

1 Draw an animal at rest, whether at home, in the park, or at the zoo (not from a photographic image). Approach it as you would a portrait of a person.

2 Draw an animal, whether the same as in the first drawing or another, in action (eating, pacing, scratching, pecking, licking, and so on). Approach it as you would an action drawing of a person.

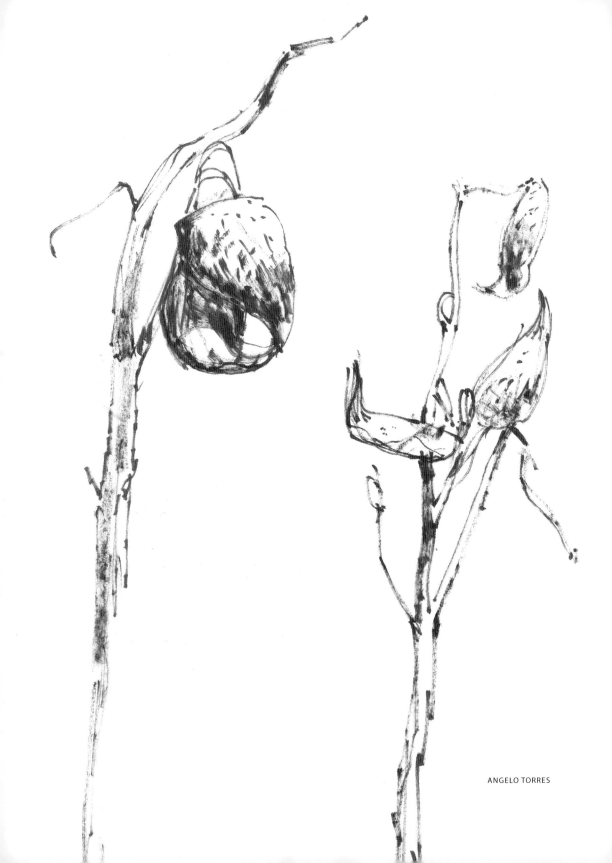

ANGELO TORRES

CHAPTER

Critical Condition

The Smell of Success
Isn't Worth a Scent

I once asked a writer friend what he was working on and he said wryly: "I'm writing a hit play!" He knows what all playwrights know: You can't write a hit. You can only write a play and have it performed. The public will then determine if it's a hit. Neil Simon wrote more commercial successes than any other living playwright, but even he would be the first to tell you he never knew which of his plays would ultimately become a "hit." It's totally out of his control. What he does control is the time and energy he devotes, and the personal statement he makes in his writing. When he writes "The End," the curtain goes down on both his play and his control of its success.

Likewise, an artist cannot set out to draw a masterpiece. Nor can an artist predict accurately which of his works will get the most favorable response.

There are those who believe that art critics wield the power to make that determination.

Fortunately, they don't!

The words "critic" and "criticism" have evolved into two distinct meanings. If we examine the etymology of the word "critic," we find that it derives from the Greek *krinein*, "to judge or discern." In the purest form of the word, it connotes an objective, scientific, or analytic method of observing a work of art. Those acting as "critics," therefore, should be expected to comment on or explain specific aspects of art in terms of form, content, execution, etc.

Instead, we have gradually moved away from using the words "critic" and "criticism" in the original manner. The popular shift has led to the use of the word "criticism" to mean "finding fault with." And "critical analysis" has come to mean "expressing disapproval" rather than appraising a work objectively. A "critic" is one who finds fault. A blatant example is today's film

SHELLY SACKS

critic who should educate us on aspects of the film's art. All too often, however, he assumes that it is his responsibility to stress a film's flaws and validate his own "expertise" by attempting to top the wit of the movie creators with his own. And if all that isn't enough, he then assigns the work an arbitrary numerical rating for commercial consumption. Simply stated, it appears that the starting point for the typical film critic today is a negative one—i.e., what's wrong with the film, rather than its contribution.

Aware that the negative approach serves as little purpose as the often insincere hyperpositive approach in classroom critiques, I endeavored to avoid responses that judged a work "good" or "bad." Nor did I include words that gave a "good," "better," or "best" spin to the process when describing a student's art. My positive statements were limited to the artist's response and insights: "Good observation," "well seen," "nice feeling," etc. (but only if I believed them to be so).

SHELLY SACKS

How does all of this relate to you? Unfortunately, negativity has become fashionable in all aspects of everyday life. And the negative approach to "criticism" appears to be the more common one. Don't believe for a moment that "sticks and stones" nonsense. Words *can* and *do* hurt, however indirectly and regardless of their source or "well-meaning" intent. The artist, with his or her insecurities, internalizes the critic's remarks and negativity and the result is that the "critic within" can take over and easily damage your growth as an artist.

SHELLY SACKS

What happens when we alleviate those external and internal pressures and kick out the critic within? The "artist" alone is then free to create and express without pressure, restriction, or inhibition. We must therefore focus our energies on identifying that part of ourselves that "finds fault" and "disapproves" of our own work—that voice which tends to be self-deprecating, insecure, and negative. And we must learn how to cognitively re-frame these negative voices and turn these destructive energies around.

Bear in mind that any sincere, personal attempt to express oneself in any art form can never be "bad." Art exists in a context of total subjectivity. There is no factual way to prove that any art is "bad." Art produces variance. That's the goal.

Math and chemistry are highly creative sciences in

SHELLY SACKS

TIM SHAMEY

GERRY GERSTEN

their experimental stages. But the goal in science is exactness and predictability, and this is the antithesis of variance. The aim of science is to duplicate the work and establish a formula that has consistent results. Twenty mathematicians seek to arrive at the same solution. Twenty scientists trying to replicate the findings of an experiment strive to achieve the same results.

In art the goal is diametrically opposite. In a drawing "experiment," twenty artists observing the same model will produce twenty different drawings. In mathematics, $2 + 2 = 5$ is wrong, and twenty

mathematicians will invariably add 2 + 2 and arrive at 4. Creativity in math, especially while balancing a checkbook or being audited by the IRS, isn't appreciated. Not so in an art class. Again, fill the room with twenty artists drawing the same subject and this will yield just as many different responses. Each response will be as individual and distinct as the artist or the signature their work bears. And, most importantly, none of the drawings can be "bad."

Hold on a moment! Don't pop open the champagne yet! Now that you've learned that you're incapable of making a "bad" drawing, you must also learn to accept that you're incapable of making a "good" drawing. "Good" is just as impossible to prove in the world of art. What we're left with is a totally subjective world wherein, by nonfactual agreement, masterpieces are selected and geniuses

are appointed. To be designated a genius and to create a master-piece is totally out of your hands. A discerning public, an educated society, a cultured environment, and, of course, the passage of time—these are the determining factors. There is nothing factual or objective about the choices. Nor is there anything you can do about it.

With all of this in mind, it makes no sense and serves no purpose for any of us to try to determine whether our work is good or bad. Let us, instead, concentrate on *creating* rather than *judging*. We should reestablish our goals so that we strive for *satisfaction* (enjoying our work) rather than *perfection*. (If we think of "perfect" as "absolute" or "complete" instead of "flawless," we have only to *complete* a drawing to make it *perfect*!)

MURRAY TINKELMAN

Drawing without concern about "making a drawing" is what personal, sincere self-expression is all about. And the wonderful paradox is that the work that is sincere, personal, and created for one's own satisfaction is what is most often celebrated by both critics and public alike. In modern parlance that's known as a win–win situation!

Let us further experience the difference between artist and critic by way of your next . . .

ASSIGNMENT:
The Judge is Benched

It's important that you not be concerned about accuracy or photographic realism here. Your prime objective is to create visual communication in simple, carefree terms of what something looks like. Again, use whichever medium you prefer.

1　Draw a familiar, inanimate object, such as a lamp, kitchen utensil, seashell, candleholder, or hairbrush, without laboring over details.

2　Now, draw that same object with as much accuracy and detail as you can using the same medium you chose for the first drawing.

3　Compare the drawings.

You will probably note several differences, but rather than focus in on which is "better," ask yourself which drawing did you enjoy doing more.

C.F. PAYNE

CHAPTER 7

Sketchbook *Sí*, Camera *No!*

It's a Pad, Pad World Out There

THOMAS B. ALLEN

A sketchbook "can transform a moment in time into a timeless moment." Many of the letters I received from students years after they attended my classes claimed that this quote in particular had a lasting effect on their work.

While the words may be mine, the practice of carrying a sketchbook isn't an original concept. Artists have carried sketchbooks since cavemen tried to bind stone slabs together so they could do on-the-spot sketches of the mammoth hunt. If I can impress upon every reader, both absolute beginner and accomplished artist, the importance of maintaining a chronicle of their spontaneous graphic responses to life, I will have achieved much of my goal in writing this book.

A sketchbook offers the opportunity for frequent exploration into the *why*, to find out who we are on paper. An artist's individuality, as complex a matrix of variables as Aunt Agnes' chicken soup recipe, is determined by the three basic elements we addressed earlier:

What we *see*, what we *feel*, what we *think*.

What we *see* begins the process of what we call the artist's aesthetic response. For example, Pat, one of my students, described a sketchbook drawing she had done of a stranger:

"The way she was sitting there, slouched in her chair like she had worked hard all day, with the light falling dramatically across her upper lip and chin, well, I *had* to draw it."

What we *feel* in this case is told by the choice of words, "I *had* to (a compulsion to capture the image) draw it." No longer personal, the "it" refers to the *scene*, the *pose*, the "*model*," be it a person or a bowl of fruit.

What we *think* is evident in our belief that the subject's pose indicated her exhaustion from physical labor. That may very well be the case, but, truth be told, she may have been partying all night! It doesn't matter. What *does* matter is that this artist's response to the scenario, however accurate or flawed, was a *drawing*. To spend time observing without drawing, thinking without drawing, or feeling without drawing, is the misfortune of nonartists.

The drawing novice in particular is notorious for getting bogged down in the "right materials" before they attempt work. Too much of their drawing time is wasted on problems concerning the *how*. Sketchbook drawing eliminates that consideration by minimizing

TOM FEELINGS

the requirements for the work, that is, just a pad and drawing in-strument and ZAP—you're in drawing mode.

Sketchbook response also keeps us focused on life rather than *images* of life. I don't recall an instance in which my students did not challenge this concept, at least initially.

"Why this insistence on drawing from life? Isn't drawing from photos the same thing? And a lot more convenient?"

Answer: Those of us with normal vision see everything three-dimensionally. Photographic images, whether in print, or on a TV,

computer or movie screen, *appear* to be three-dimensional, but in reality are two-dimensional.

With the exception of sculpture, an artist's response to three-dimensional form takes place on a two-dimensional surface. In representational drawing and painting the artist can only create an *illusion* of three-dimensional form. This is usually done through an awareness of light and shade. Nature provides a constant principle

to rely upon: the plane closest to the light source appears brightest and the furthest plane appears darkest. Through on-the-spot drawing experiences artists can unconsciously gain awareness of nature's "lessons" like these.

To the contrary, there are distortions in perspective that occur when we limit our graphic response to the outlines of the images of a photograph. In a photo, each form has *already* been reduced to two-dimensionality, so that following form ignores the actual *depth* of those shapes.

Moreover, the "model" in a photograph doesn't live, breathe, itch, or scratch. The subject may just as well be a store mannequin.

In other words, a photograph locks in a moment of life "factually." A drawing locks in that moment "expressively."

Once we accept that "factual" image, we don't question its elements. Fold patterns, anatomical distortion caused by perspective, lens, etc., become the points of reference from which the drawing would evolve. The artist's response is reduced to a more mechanical one, reproducing one image from another, and, thus, restricting creativity.

This is not to suggest that photography is more of a mechanical process than a creative one. To the contrary, a camera in the hands of one artist can wield as much personality and individuality as a brush in the hands of another. But twenty identical cameras set up in the same location with the same lighting, film, lens opening and shutter speed, processed in an exact manner, *will produce* twenty identical copies.

It is the creativity of the photographer who "sees the picture" in the mind's eye, selects the composition, chooses the camera's vantage point, and adjusts those mechanical variables that defines the individualized artistic contribution. Not unlike a sketchbook artist. It is no surprise that Henri Cartier-Bresson, the celebrated photographer, believed that, "Art is inseparable from daily life."

Like Hank Aaron's bat, Pete Sampras' tennis racket, Tiger Woods' golf club and John Singer Sargent's sable brush, it ain't the tool that's creative, it is the artist behind the tool.

In sketchbook drawing, avoid any attempt to do a "definitive" work. Approach each session as if it is one of countless others to follow. If you treat each drawing as if it's the last one you'll ever do, you're making impossible demands upon yourself. You are expecting each of your drawings to showcase the totality of your talent. Who needs that kind of pressure added to the list of all the others we conjure up for ourselves? It's *fun* to draw. Let each drawing be just *that*!

No more philosophy! Pick up your sketchbook and have fun doing the next . . .

tein, Switzerland 8.12.78 Fussball: Germans and Swiss. Holl

BRAD HOLLAND

DANIEL BENNETT SCHWARTZ

ASSIGNMENT:
A Moving Experience

Body language plays a major role in our lives. This
assignment will help you experience telling a complete
story through action, mood, gesture, and attitude.

1 Observe a person busy doing something.

2 Draw that person, full figure, and focus on capturing
 the *action*, or *motion*, he or she is engaged in.

3 Next, draw that same person, this time focusing on the
 details so that a complete story is told through clothing,
 costume, uniform, or any other accoutrements or details
 that add to the viewer's knowledge about the subject.

BRAD HOLLAND

Believing Isn't Seeing

Perception Can Be Deception

HENRI DE TOULOUSE-LAUTREC

I often use the work of Henri de Toulouse-Lautrec to make certain points in the classroom. Toulouse-Lautrec's sensitivity to the human condition was manifested in every work. His drawing response to form and motion was spontaneous and direct. One of my students who had difficulty drawing figures proportionately approached me one evening and said in a confrontational tone,

"In several examples I notice that Toulouse-Lautrec's figures aren't perfectly proportioned."

"Neither was Toulouse-Lautrec," I countered, getting a laugh from the class to segue into what I sensed would be a serious

NICK MEGLIN

exchange. "Are you asking how come it's acceptable for Toulouse-Lautrec to draw figures out of proportion and not okay for you?"

"Well, yes."

"Before you judge Toulouse-Lautrec's work consider this—we don't know if those figures you speak of are malproportioned or accurate renditions of his subjects. We weren't standing by his side as he drew. Not to mention that Toulouse-Lautrec's actual short physical stature may have translated into a different point of perspective. More important, whoever said your sense of proportion is 'unacceptable'? You're here to learn. I'm only trying to make you aware of the actual proportions of the model in front of you and your drawing response to him. That gives you the opportunity to make adjustments based on your observations or not. It's not a question of acceptability."

Feeling that my student was not wholly convinced, I decided to tune up the old violin and try the sentimental approach instead.

"My fellow students," I begin, "for in the true sense of the word we are always students on the highway of life . . . fellow travelers on artistic paths . . ." and so on. Then I mix metaphors by the gallon until the students are overcome with remorse, boredom, or anything else that will render them senseless! At that point, with their barriers down, I hit 'em between the eyes by explaining what happens, well, between the eyes!

It's difficult for most of us to accept, but vision can be at least as subjective as it is objective. Of all the senses, sight seems to be the most creative. As a result, it is this sense that causes the most

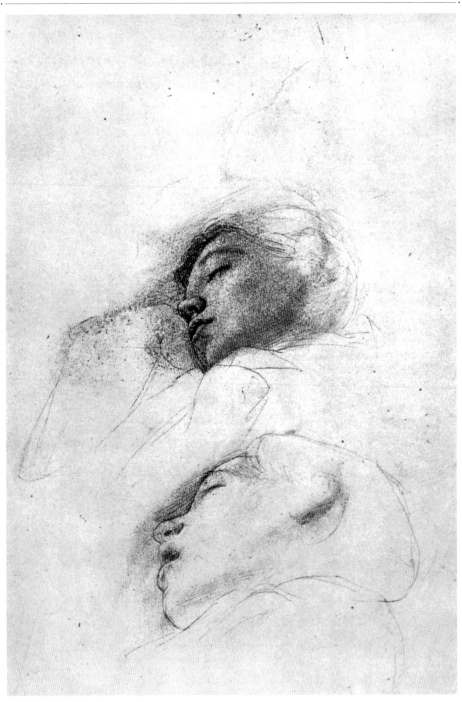

EDGAR DEGAS

problems in our everyday lives. Everyone believes their own perception is "fact" and any contradictory perception is mistaken or "not exactly the way it was." If indeed, each of us saw "fact" instead of "belief," a police officer interviewing five eyewitnesses to an auto accident would come away with five identical reports. Instead, the reports run the complete gamut—"He was at fault," "She was the cause,""The lamppost leaped out into the street and hit the Honda," and so on.

We don't *see* factually, but rather, we *perceive*. And perception is a highly creative and unconscious process. Simply stated, we see through our mind—which edits, filters, and distorts our vision, then converts the reality of an event into an opinion of what transpired. The objective "truth" is thus transformed into a subjective, personal one, which becomes our own personal experience. To use our earlier example, that is why twenty

REMBRANDT

students in an art class turn out twenty different drawings of the same model. A copying machine, free of values, judgments, opinions, and personality, responds with twenty identical copies of the original. The human machine doesn't.

Art, then, is at its "purest" level when it allows the "mind's eye" the freedom to make a personal statement. It's sad that so many

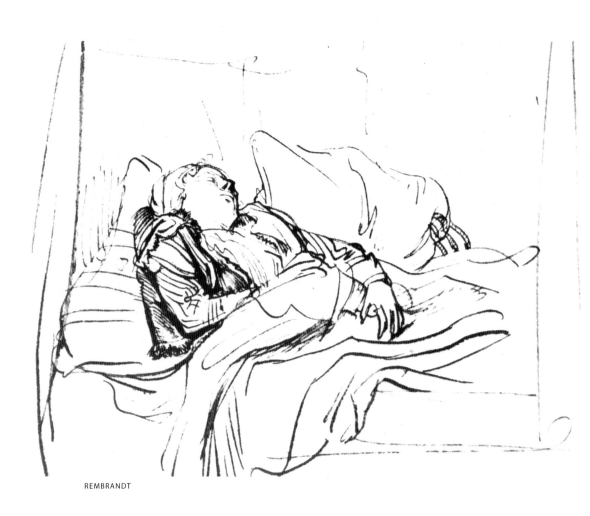

REMBRANDT

of us aspire to be computers! We're willing to trade off our "distortions" for the ability to reproduce what we see "factually" instead of leaving that job to the camera or copier.

Inanimate objects or "things" are manufactured to meet the specific needs of the "average" human form. Tables, desks, chairs, and doorways are "standard measurements" for humans. Aesthetics have little bearing on comfort. While a stairway might look more dramatic with steps that measure ten inches high, the resulting number of accident reports would soon indicate the need for

a more human-friendly designer. Expressionists are not who we want to hire to design stairways.

Years ago, automobile ad art directors often instructed illustrators to distort true measurements of both the fashion-plate

"passengers" and the vehicles in their renderings in order to promote image, style, and sophistication. The relationship between the seven-foot-tall models seen next to the low, three-foot-high sports car had nothing to do with driving comfort. It was strictly for effect. The engineer's actual schematic illustrations of that vehicle told an entirely different story from that of the ad illustration, of course. No basketball player who actually measured seven feet tall could even fit into that car, let alone drive it in comfort!

How this relates to all of us within the context of responsive drawing is that accuracy alone shouldn't be the criterion on which art is judged, despite the fact that all too often it is. Striving for "accuracy" can prevent someone from achieving far greater levels of creativity. Self-expression must emerge from one's perception. The "distortions" are a major part of a valuable personal statement.

When caught up in a "drawing problem" like proportion, it's usually a case of not seeing with objective eyes. We look but don't draw what we see. Instead, our lines seek to duplicate earlier successes. We apply solutions, shortcuts, and symbols we've picked up from our past work or the work of others that assume a more contrived approach than an objective one. To counter this barrier, it helps to focus on other criteria. If drawing the figure, for instance, draw the attitude, not the anatomy. Draw the gesture, not the detail.

In other words, a drawing of a person sleeping should look different from a drawing of that same person fully awake but with

SHELLY SACKS

closed eyes. The "body language" as well as the facial expression of a sleeping person says "sleep." Respond to that and your job gets a lot easier. And your drawing will be a lot more convincing.

And now a word from our sponsors: Try the new and improved . . .

ASSIGNMENT:
Having a Point of You

Remember, our goal is to draw, not to draw conclusions! So free your mind of preconceived images and experience a fresh start on a fresh page.

The first drawing in this assignment will be a representational one—what you see. The emphasis is on what the person is *doing*, sitting, standing, reading, sleeping, etc. Your second drawing will be a contour sketch.

1 Make two drawings from life of the same subject. If you cannot get a friend or relative to "pose" for you, find a "model" in a local library, waiting room, diner, etc. Do not focus on details such as what they're wearing, reading, or the chair they're sitting in.

2 Draw a continuous line directly on your page. Neither look at the page nor your drawing in the process. This exercise will test your integrity as well as your "achievement orientation," since you cannot correct or beautify your work when you're not looking at it. (You will have to be content with a "messy" piece of work with all "mistakes" exposed to the world.)

3 Compare the two drawings. The first is obviously more accurate in representational terms, but which has more "movement" or "aliveness"? You may be surprised that the second drawing may very well tell a more accurate story of what the person was doing.

MARK PODWAL

There's No Time Like the Pleasant

Clocks Need Two Hands, Artists Need Only One

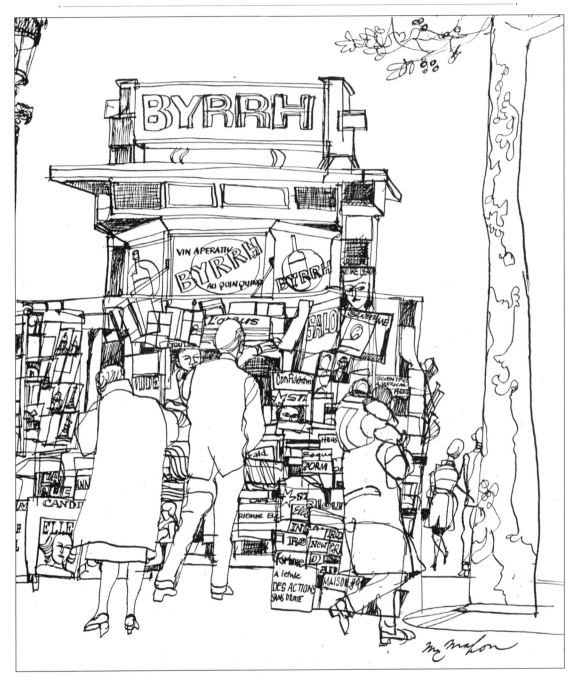

FRANKLIN McMAHON

A rt students often ask, "When is the best time to draw?"

My response is always: "Always!"

And I don't think it's a waste of time to talk about wasting time. Getting past "when" is an important hurdle in the evolution of an artist. Many of us waste precious hours trying to live our lives totally within arbitrary parameters. For example, a typical art classroom scenario goes something like this . . .

"When is the best time to eat?" I ask the class.

"When you're hungry!" a student's voice responds from the back of the room.

"Then why do you eat at noon every day? Are you really always hungry to the same degree at that time? Or is the time you

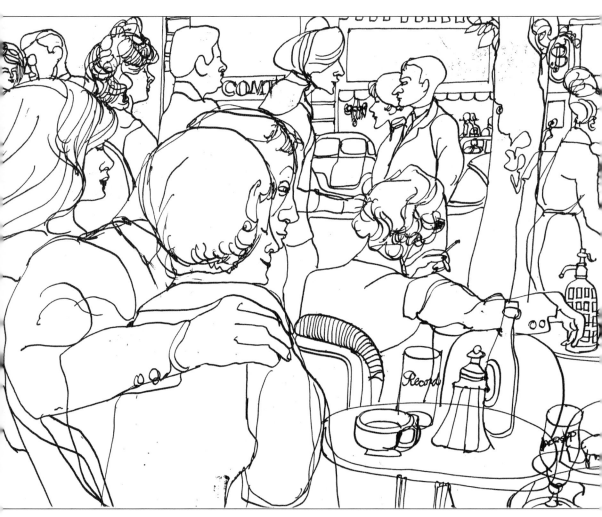

FRANKLIN McMAHON

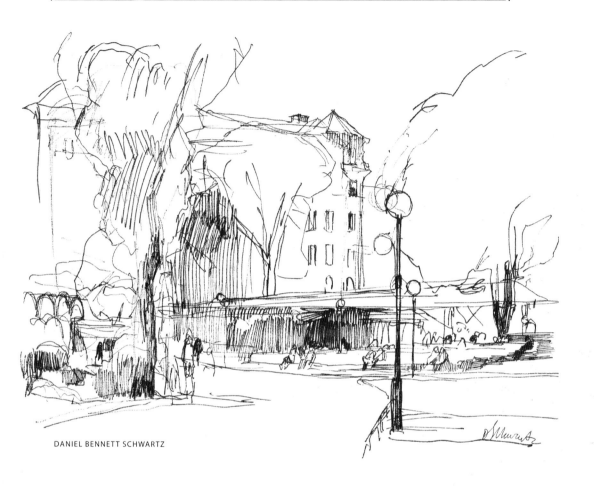

DANIEL BENNETT SCHWARTZ

eat dictated by other considerations, such as job or school sched-
ules? Do humans have set 'lunchtimes' that you and your 'hunger'
are now programmed for?"

"When's the best time to relax?" I continue.

"When you're tired!" another student answers.

"Sounds reasonable. When's the best time to draw?"

No response.

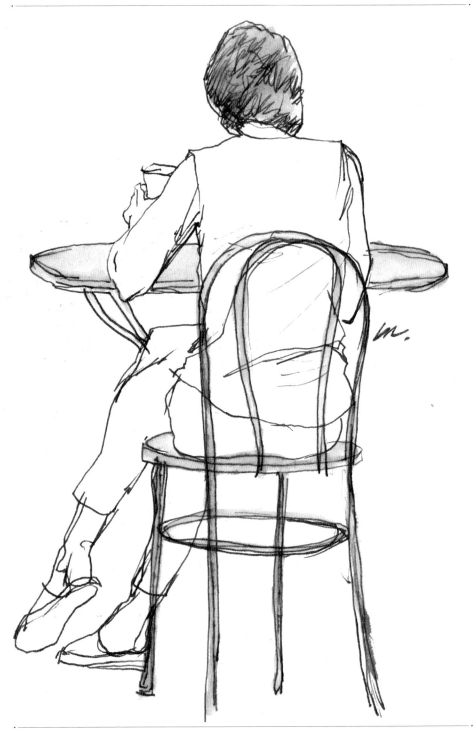

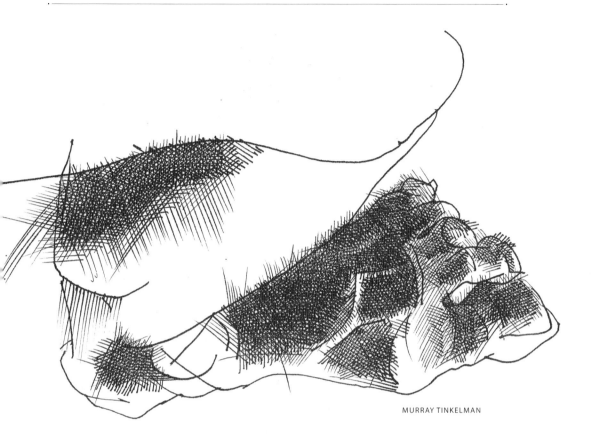

MURRAY TINKELMAN

"How about when you're eating or relaxing?"

Again, no response.

"Who ate lunch today?" I inquire.

Most hands go up.

"How many hands do you really need to hold a bologna sand-wich?" I ask rhetorically. "One hand, right?"

An affirmative nodding of heads.

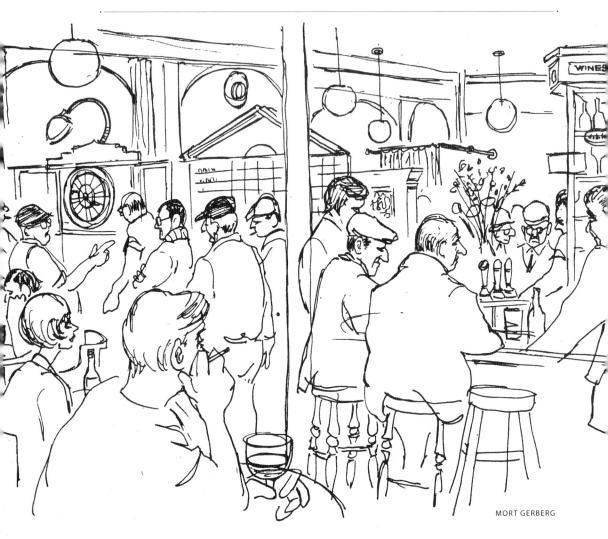

MORT GERBERG

"It doesn't have to be your drawing hand, does it? Okay, then, how many of you did a drawing at lunchtime today?"

No one raises a hand.

"Then you've wasted, say, half an hour of valuable drawing time today. Multiply that by five days a week, again by fifty-two weeks, and it adds up to far too many wasted hours every year.

"Now let's talk about rest and relaxation. How many of you have watched TV this week?"

Again, many hands go up.

"Okay, raise your hand if your life was truly enriched by watching some dopey actor smile through sixty teeth as he compared motor oils, or by some wimp not knowing which laundry detergent really works best on those tough stains?"

A few tolerant snickers, but again, no hands go up.

"Then it's fair to assume that most commercials don't contribute that much to your well-being, right? So, how many of you made drawings during commercial breaks?"

No hands.

"Why not? I'm not even attacking the television shows (most of which contribute no more to world peace than the commercials do). My point here is that if you used that precious time to draw your pet, your lamp, people in the room with you, even the *remote—something*—while the sponsors were blaring out their nonsense, by the end of the year you'd have a lot of drawings in your collection that you don't have now. We learn to draw by drawing, not watching commercials."

By the end of the semester, my students no longer believe "Always!" is a facetious answer to the question, "When is the best time to draw?" Through objective appraisal of their typical day, they have learned to find more "drawing time" than they ever knew they had before.

Our lives are dictated by clocks and calendars, and to achieve any sense of order, we obey. The boss tells us 9 to 5 and we

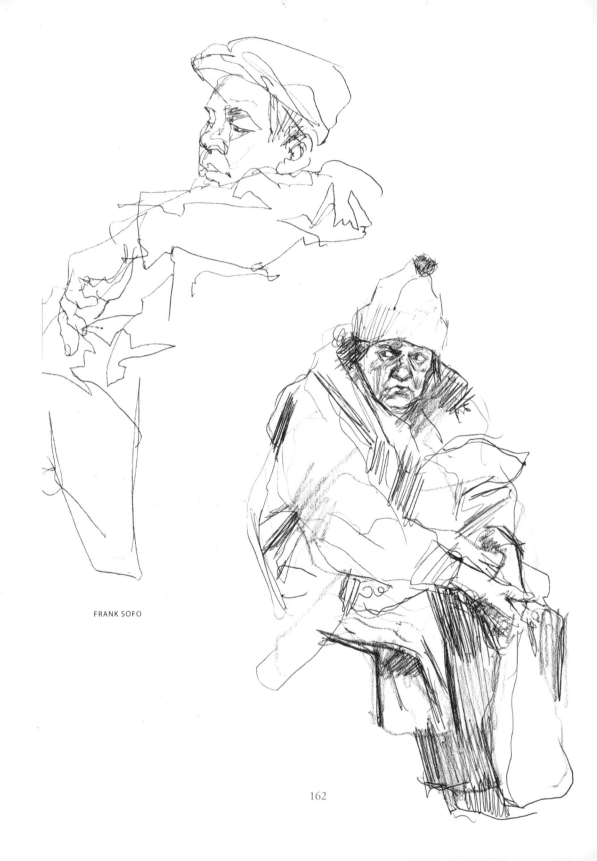

FRANK SOFO

comply (or seek other employment). Unfortunately, we expect our creative energies to adhere to the same form of programming. Too often we think of "drawing time" as "studio time." We may turn on some music and expect our artistic responses to be turned on just as easily. What we need to do is reprogram ourselves by carrying some drawing materials with us at all times. Only then will we be prepared to respond to the need/urge to express ourselves whenever and wherever that need/urge occurs. In reality, it may be while waiting on a line, sitting in a dentist's office, and, yes, in a cafeteria at lunchtime, clutching a bologna sandwich with one hand while sketching an oblivious coworker with the other.

We need to be reminded that geniuses like Leonardo da Vinci and Thomas Edison accomplished so much in the same twenty-four-hour day that we believe doesn't offer enough time for even a quick sketch. Not to mention that neither had an electric lamp to brighten up their evening work hours until the latter genius found the time to invent one!

Drawing provides more in the way of instant gratification than any other art form. Playwrights and composers require many stages (literally and figuratively) before their creative efforts come to fruition. Novelists require an extended period of time until their work takes its ultimate form as a published book. Architects also have to delay their gratification from their initial sketches to the actual construction of the buildings they've designed. Actors, singers, dancers, and musicians all require an audience (no easy

accomplishment) and certainly do not achieve their goal instantly. But an artist has only to respond to his or her visual stimulation by drawing it and—ZAP! Satisfaction!

See for yourself by starting on your next . . .

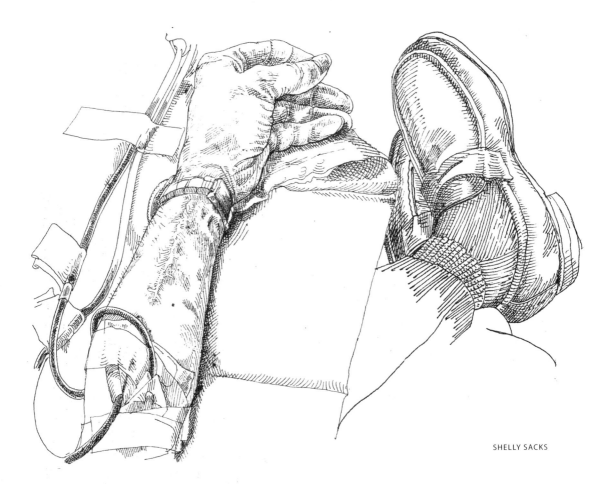

SHELLY SACKS

ASSIGNMENT:
The Clock Strikes When

There are two assignments for this chapter; the first is a

nondrawing exercise.

1 Create a "time log" that will chart your activities for a full
 week. Be as objective as you can as you note in particu-
 lar those times, however brief, when you might have
 been able to at least begin an on-the-spot drawing.
 Remember, this is an *objective* diary, compiled without
 judgment. You are not wrong nor at fault for "wasting
 time." You may not have ever thought
 of utilizing those moments in an artis-
 tically constructive way before.

2 Make a drawing during one of these
 heretofore "nondrawing" times. For instance,
 have a pad and drawing instrument ready to
 use while you are watching television. When
 that commercial begins to drone on about
 how the quality of life on our planet will
 improve when you purchase that Nirvana
 500, it's time to *start drawing*!

ANGELO TORRES

AT THE CLOISTERS

CHAPTER **10**

For Better or Versus

The AND Justifies the Means

JEAN-BAPTISTE COROT

The local "Arts 'R' Us" supply shop got it right! The sign says, "Arts *and* Crafts." Not "Arts *versus* Crafts." Or, worst of all, "Art *is* Craft."

Art and craft are two sides of the same coin, inseparable, but best left to develop naturally through experience.

Michelangelo's romantic notion about just being the middle-man between the uncut stone and his statue of David couldn't be further from the truth.

"David was already in the marble," said ol' Mike. "I just took away everything that wasn't David."

No, his miraculous sculptures weren't captives in stone waiting for any chiseler to come along and chip away their marble

prisons. Mike's modest words, however sincere, had little to do with artistic reality.

Unfortunately, many people involved in the art process, whether instructors, businesspeople, or the artists themselves, subscribe to a perception just as flawed. Namely, that craft is what art is all about. Rendering expertise, they maintain, is the better part of any artistic endeavor. They rhapsodize over such matters as pencil dexterity, pen fluidity, and masterful brushwork, all *how* to do

GIORGIO MORANDI

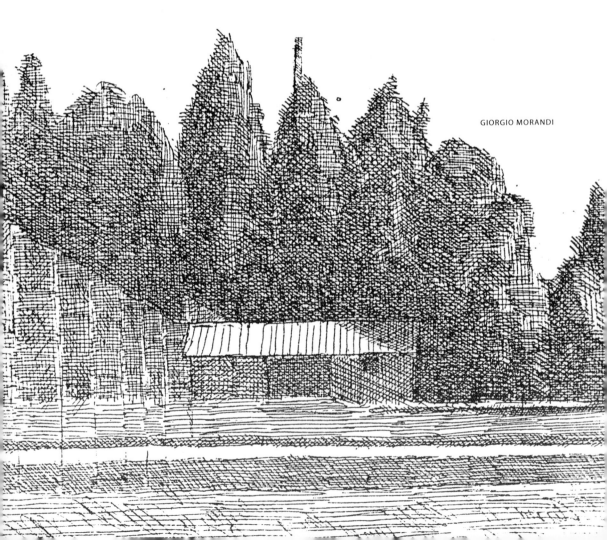

art and no *why*. The reason most often is self-serving: Proficient technicians, devoid of a personal statement, would rather define an artist's role in the creative process in ways that emphasize their own limited contribution, craft, and technique. Far too many students have internalized those values. This is unfortunate, because art is about *why*, not *how*.

A playwright who has nothing to say, but has the ability to write dialogue poetically and with great flair, still says nothing. Or, in a more graphic example, those people involved in building construction had better be more concerned with the *what* and *why* of the architect's work than with the *how*. Beautifully rendered drawings of a building presented by a master craftsman with little talent in the art of stress points . . . well, you'd best avoid taking shelter in a building of his design in a heavy storm!

If there is sincere, personal response to the creative inspiration, the craft will be inherent in the art and not a contrivance apart from it. As discussed initially in chapter one ("Materials Are Immaterial"), the primary purpose of line is search, not solution. The end result is a statement, not an effect.

Just for a moment, let's leave our judgmental tendencies in the sealed metal container with those old paint rags and flammable materials (so as to prevent combustion and burnout of our better senses). Good. Now consider the work of Vincent van Gogh once again. Ol' Vinnie *expressed* himself without trying to *impress*. His struggle was with saying what he had to say, not mastering his materials.

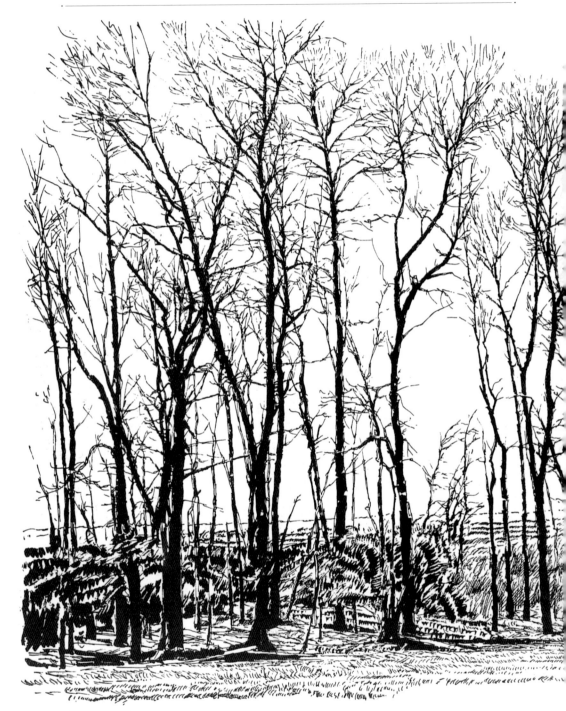

ANTHONY SARIS

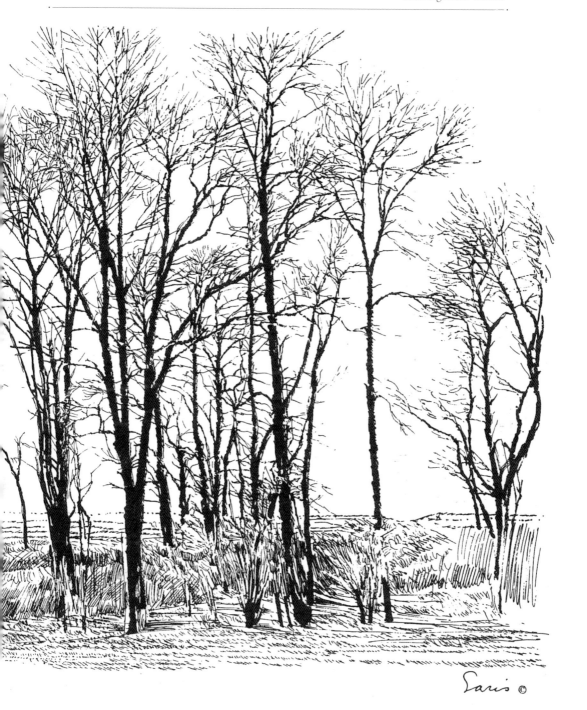

Remember, skill in draftsmanship evolves after years of drawing, painting, sculpting, etc. It's rarely present at the beginning of one's active drawing life. To prioritize rendering before natural response is to limit your growth as an artist to an almost critical degree.

In the same vein, I've heard many students talk about "developing their technique" in a way that translates into nothing more than their own belief in a system or formula for achieving drawing success. There are no guarantees in any artistic endeavor except one: There are no successful formulas!

A list of "great artists" always includes the names of the most individual, most innovative, most daring, and the greatest risk-takers. If there is any such "guarantee," it appears to be with those who respond intuitively rather than those who place their energies in the pursuit of the surefire methods. Contrived measures are the antithesis of personal intuitive artistic response, the one constant factor in all art that has been deemed "successful" universally.

Unconsciously relying on what we already know is a miracle of daily living. For instance, if we wait to *think* about what the red light means and how to use our foot to hit the brake pedal, we would find ourselves in the middle of an intersection with an eighteen-wheeler across our abdomen. I'd rather share the road with experienced drivers than with people who have read dozens of driver-education manuals but have never been behind the wheel! Even the best book ever written on "How to Swim" won't keep you afloat if you never jump into a pool to experience the act of swimming.

Learning to draw is no different. Just reading books on the subject (including this one) won't help you a fraction as much as what you'll learn by drawing responsively and drawing often. The best book on the subject is your sketchbook!

Open it up and start on the next . . .

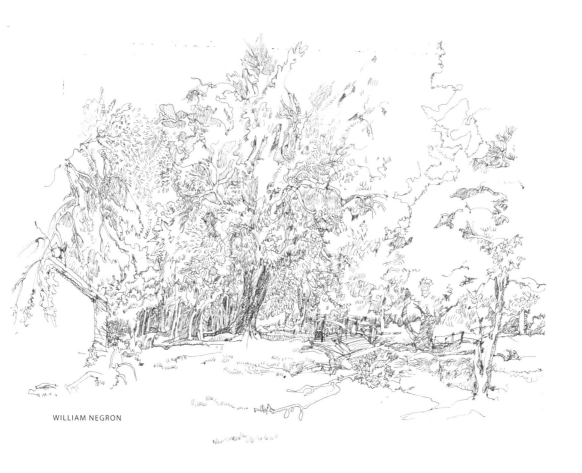

WILLIAM NEGRON

ASSIGNMENT:
The Oak's on You

In your daily travels, scout the area for a tree you'd like to draw. Check out the leaves or the bare limbs (depending on the seasonal effect). Be aware of the texture of the bark or the smoothness of the leaves. Don't isolate the subject; observe it in its natural surroundings.

Or, if you prefer, draw one of your "best-friend" plants (you know—the one you talk to the most).

1 Using any medium you prefer, draw a "portrait" of the tree or plant as you would a person, capturing the "likeness" representationally.

2 Do a second drawing of your subject from a completely different vantage point, size, or approach (e.g., impression as opposed to detailed study).

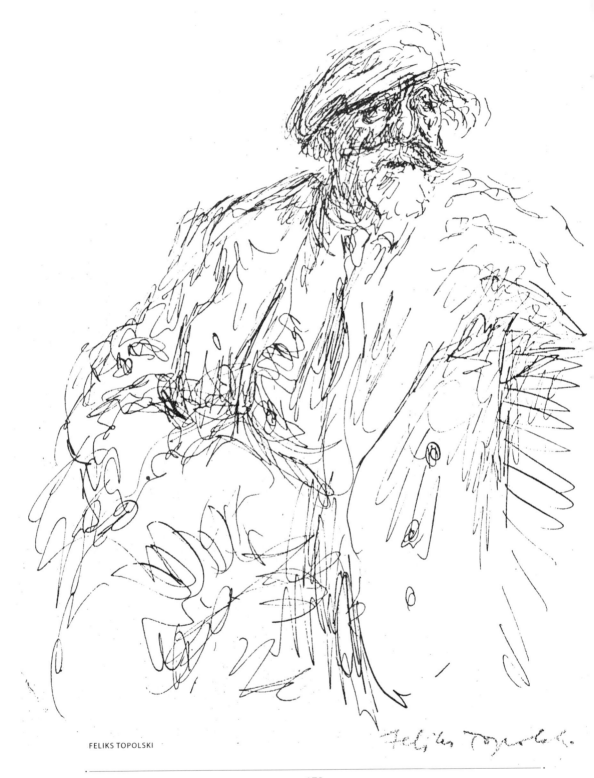

FELIKS TOPOLSKI

CHAPTER 11

Imitation Ain't Inspiration

Visitation Rights and Wrongs

A unt Agnes is a problem. Don't get me wrong. I have no ill feelings against Aunt Agnes personally. I rather like her, and I know she means well. And I certainly wouldn't want to give up eating her chicken soup—it's to die for! (Wait, that's wrong—her chicken soup is so therapeutic it's actually to live for!) My problem with Aunt Agnes is that all the positive feedback she's given you over the years has had a negative result. She liked your work for the wrong reasons. Remember way back when she raved about your ability to neatly crayon within the lines of your coloring book? And later how she delighted at your amazing ability to copy?

"Your drawing of Bugs Bunny is more real than the one on TV!" she exclaimed.

WILLIAM A. SMITH

And it wasn't that long ago when she marveled at your rendition of a Renoir floral painting.

"Better than the original," she declared.

Poor Aunt Agnes. She couldn't have known that you might take her words seriously, that you believed her opinion to be fact. So here you are today, rendering neatly between the lines, imitating

REMBRANDT

your favorites, and stuck in art limbo without anything to say except an echo of what's been said by others.

Well, the stuck stops here!

As an artist you have nothing to offer but yourself, your own personal vision. Everything that has been done by others has been done by others better than anything you can do because you're not them. So why bother? The one thing other art-

ists cannot be better at than
you is being you!

The difference between inspiration and imitation is the actual starting point at which work begins. To quote Pat, the young lady in chapter seven, as she described a sketchbook drawing she had done of a stranger:

"The way she was sitting there, slouched in her chair like she had worked hard all day, with the light falling dramatically across her upper lip and chin, well, I *had* to draw it."

It was Pat's personal experience that served as the stimulus to which she responded graphically. That's *inspiration*.

To pick up where another artist left off is *imitation*, nothing else. You can't see what they saw, you can't feel what they felt, you can't think what they thought, you can't eat what they ate! Why would you want to?

JOHN GUNDELFINGER

GEORGES SEURAT

SHELLY SACKS?

This is not to say that there aren't any advantages to outside influence in an artist's development. To read about the life of a favorite artist and view his work in that context can be both inspirational and educational. Learning *why* Pissarro responded to *his* environment in *his* way may certainly inspire you to respond to *your* environment *your* way. But to learn that Pissarro liked to blend Cerulean Blue with Cadmium Yellow Light, however, only tells us that Pissarro liked to blend Cerulean Blue with Cadmium Yellow Light. What value is that to *your* personal vision? How you interpret your world is a unique and valuable commodity. You neither have to learn it or

SHELLY SACKS

understand it. Just apply it. It's right there for the taking. Why accept anyone else's vision as your own?

You can never be faulted for doing personal, original work that looks like yours alone. You can only be faulted for not!

It's that delightful time again for you to stop reading, get out your pad, and start drawing your . . .

ASSIGNMENT:
A Pose Is a Pose Is a Pose

Where you draw this assignment is more impor-
tant than whom you draw, since, hopefully, your
subjects won't be aware you're capturing them for
artistic posterity. Choose a diner, waiting room,
playground, airport, etc., where you can observe
and draw "models" undetected. Don't waste valu-
able time drawing chairs, benches, and
other objects that can be completed later,
even after your subject has left the scene.

1 Do a portrait of a person.

2 Do a portrait of another person on the same page.

3 Right! Do a portrait of yet another person, also on
 that same page.

Needless to say, you don't have to stop after three.
The more you do, the more comfortable you'll
become, the more confidence you'll derive, and
most important, the more satisfaction you'll allow
yourself to experience.

JOHN GUNDELFINGER

Learning Is A Churning Experience

There Are No Runs and
No Hits Without Errors

WILLIAM NEGRON

Making mistakes doesn't make you less of an artist, but not learning from them can. The learning process hasn't changed from the time we were all infants. Babies learn to walk because they aren't judgmental. They don't feel embarrassed about falling. They don't feel proud of themselves for getting up and trying again. Their goal is to walk. They do what they have to do in order to achieve that goal without thinking, analyzing, and most important, without *judging* their own performance.

We all carry that free, uninhibited spirit to our initial drawing experiences. As children, most of us create our early masterpieces with crayon. We either colored on the paper that was provided to

TULKA

RICK TULKA

us or on a bedroom wall where our masterpieces met with markedly less enthusiasm. In time, the wonderful age of innocence gets intruded upon by parents, teachers, etc., ushering in the values and comparisons that can forever inhibit our freedom of expression. If we let this happen, a new level of awareness takes hold, and words like "mistake" and "imperfection" become our standard of comparison.

ANGELO TORRES

JOHN GUNDELFINGER

"Learn from your mistakes" is a hackneyed phrase. But it has earned its place among other popular gems elected to the "Cliché Hall of Fame" because it's true. What a pain! Learning from our mistakes certainly can happen in drawing if we allow this to occur. Unfortunately, many artists don't want to. I've observed many students who would rather destroy their "bad" drawing and start a new one rather than correct their "errors." To combat this tendency, I would ambush them by proclaiming:

"Tonight will be One Shot Night, folks! You go with the flow, and draw with the flaw! Every line gets used! Not one drawing gets slam-dunked in the basket tonight!"

Despite rumblings like, "The sadist is at it again!" I stuck steadfastly to my mandate.

"There are no mistakes, just lines that you're not happy with."

One brave lad asked, "Why isn't this head I've just drawn a mistake? It's way out of proportion with the body. And it looks wrong."

"It's not about right and wrong, it's about seeing and responding. Looking and drawing. So take as many looks as you'd like. Make as many responses on your drawing as you'd like. And don't erase anything! I assure you that you will learn more from drawing a new line over your old line than by erasing or destroying it."

"But it looks so messy when you do that."

"To whom? Not to me! It doesn't bother me in the least. It shouldn't bother you, either. You're a student, and you're here to learn who you are on paper and not make neat, clean, or 'pretty' drawings. So who else factors into the equation? Aunt Agnes? If

you want to produce art that will please her, it ain't gonna happen here. It's a lot easier to buy a paint-by-number set and mesmerize her with your artistic genius that way!"

"I've read about many famous artists who destroyed drawings and paintings they didn't like," another student challenged.

My response to that comment addresses the two major time frames inherent in any drawing. How long it takes the artist to cre-

Harbor View.
Isle of H
Yugosla.

MORT GERBERG

ate it is one time frame. A quick sketch, for instance, can take only minutes. The second time frame is how long it took the artist to get to that point in their drawing "career." This must be measured by their lifetime. An artist's "vision" is an amalgam of his or her life's experiences: everything they saw, felt, learned, imagined, believed in, etc. There is no choice involved. It's an evolutionary process combining all senses, memories, fantasies, facts, and fictions. With so much energy invested into each piece of work it's no wonder an artist feels passionate about the fruits of his labor. He hangs some drawings and paintings with pride and destroys others in frustration. That's an experienced artist's prerogative.

But not a novice artist's!

Another familiar question often raised is about the use of guidelines (whether ovals, matchstick figures or other popular "blueprints" for figure construction):

"My drawings of the model are more accurate when I start with guidelines. But you discourage it in this class."

"Not true! I encourage you to draw *everything* you see. If you *truly see* guidelines, by all means *draw* them. If there aren't any, then why would you want to draw them?"

"Because they help me control the form," is the reply.

"That's the problem! Guidelines create a schematic for all forms, the model, me, her, him, even your form. Once you stop seeing each individual as they exist, you stop responding to each individual whom you're drawing. They become idealized. They conform to aesthetic taste and cease existing as they are. And in that

process the artist ends his life as a responsive participant and begins his life as a robotic follower of formulaic solutions. Other than that, there's nothing wrong with guidelines!"

They usually got the point.

Another common problem was: "I'm having a *bad night*."

Having endured many myself, my response was always empathetic.

"When you're not having a good time of it, it doesn't get better if you push yourself." One way to deal with the problem of lost confidence is to return to the basics. Take a hard look, think about your subject, then attempt to draw the most of what it is. If it's an inanimate object, what is its purpose? What does it do? What is it used for? If it's a figure, what is the action, the attitude, the gesture? Then stop thinking and start drawing that. It often helps to concentrate on the sensate aspect of drawings—how the pen feels gliding across the pad or the 'grab' of the graphite, carbon, or charcoal against the texture of the paper. Be aware of the distinct, albeit barely audible sound of each instrument as it makes contact with the drawing surface. Ah, that soft sound of the pen gliding across the paper. Ah, that crunchy sound of the charcoal biting the textured surface of the page. Ah, the romance of drawing.

"Above all, don't strive for *perfection*!"

"Then what is our goal supposed to be if not perfection?"

"Perfection doesn't exist in the abstract world of art, so why frustrate yourself trying to achieve it?"

What you can achieve is a sincere, personal artistic response to visual stimulation. That's worth aspiring to because you're capable of achieving your goal with every drawing you make. When you don't know you've given up something, you've given up nothing. Awareness makes the difference. And if you're not aware of making a mistake, you haven't made one. It is only through self-awareness or communication from others that you realize a mistake has been made. Only then can you do something about it (if you choose to).

WILLIAM NEGRON

Knowing your drawings will never be perfect (or imperfect), you're free to have fun drawing without those inhibiting considerations. And having fun drawing, well, "*that's* perfection!"

And what's the perfect thing to do right now? You got it! Get artistically involved with the next . . .

JOHN GUNDELFINGER

ASSIGNMENT:
The Lone Arranger Rides Again

Let the eye choose a graphic image from which to start. You're walking down a street and see buildings, or trees, or something else "arranged" in an interesting composition. Or, you're in a restaurant and you notice salt-and-pepper shakers, utensils, ketchup bottle, mustard jar, wineglass, whatever.

In this two-part assignment, your goal is to draw what you see in an "arrangement" of how you'd like to see it.

1 Draw an *exterior* scene utilizing only those subjects or forms you *wish* to include in the composition.

2 Draw an *interior* arrangement utilizing only those subjects or forms you *wish* to include in the composition.

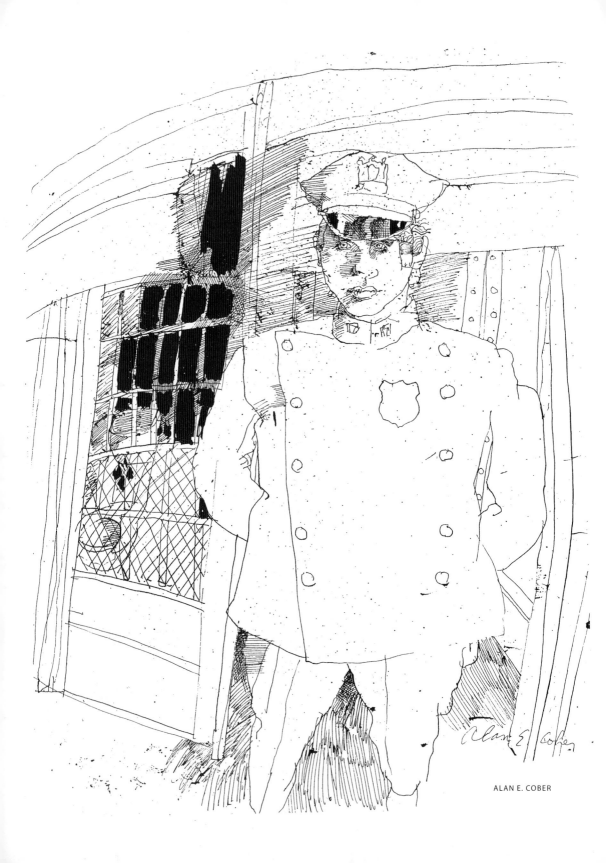

ALAN E. COBER

A Drawing Exorcise

Comes the Evolution

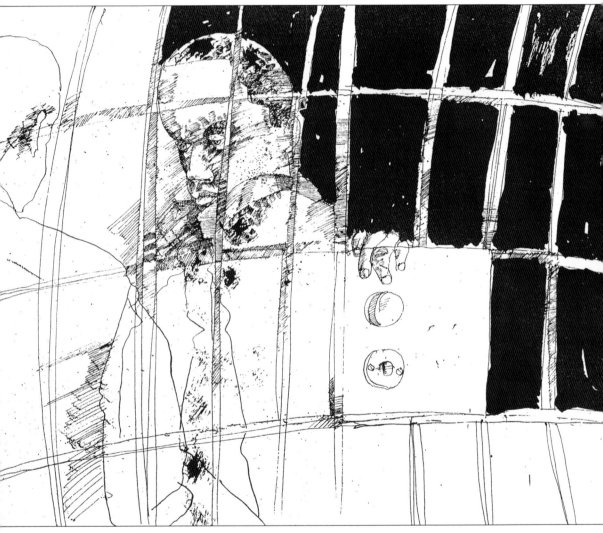

ALAN E. COBER

he creative process often provides answers when no questions were asked, arrives at solutions where problems weren't apparent, and ties into neat packages many thoughts and ideas that were previously isolated or unrelated. This process isn't unique to the art of drawing alone. It is true of each form and fashion of art and it's true of all creative endeavors.

So much of our creativity emerges from the unconscious that we are often mystified by its origin. Seminars where fiction writers conduct question-and-answer periods about their work are filled with questions like, "Where do you get your ideas?" and "What's more important, the characters or the plot?" for which, unfortunately, there are no meaningful answers. Unless there's

an obvious cause and effect operating, and the writer is basing a work on a specific event or experience, ideas emerge through an individual and complex filtering system that defies rational explanation.

Because this cannot be accurately explained, the "how" often becomes the path most traveled by seekers of solutions to "why" problems. In the art of drawing, books on techniques and methods abound. Most of these books offer step-by-step formulas and cookbook approaches (recipes!) to the creative process. They promote trendy, pseudopsychological ideas and promise instant success. Although limited and contrived, these approaches have worked their way into the creative lives of unknowing artists. And they have also worked their way into the creative mainstream. Thus, in these cases, fiction has become fact and style has substituted for substance.

Our natural drawing response stems from our earliest artistic attempts which are, for the most part, entirely subjective. Children begin their drawing of the human form, houses, airplanes, animals, trucks, etc., from memory. At that stage in their life, they don't check out the subject as they draw it and thus are really creating symbols. For instance, most children begin sketching the human form by drawing the head first, working their way down the body to the legs and feet, and do not usually stop their downward progression to include arms and hands.

Later on, as their experiences and observations add more realism to their work, their "memory" drawings become more sophisticated. They begin to draw the human form and other common

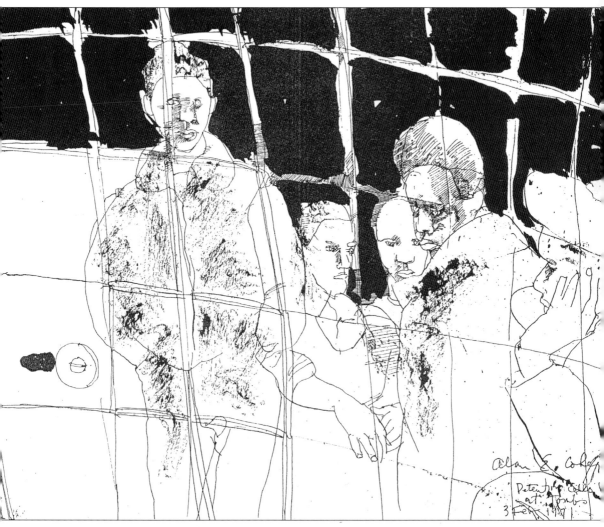

ALAN E. COBER

subjects more accurately. They now show arms, ears, and other extremities missing from their earlier works. They also show hints of representational awareness, such as placing forms in perspective with hints of light and shade. In the classroom setting, as I observed my adult students' responses to the live model, I found that most of them still started their drawing with primary indication of the model's head and worked downward.

Interestingly, most children start drawing tree trunks first, working upward. When I asked my students at what point did they begin their drawing for the "draw a tree" assignment, they too identified the trunk as their point of departure. Some things never change.

Once habits and approaches are formed, they become part of the individual's natural response. There's nothing to be gained by trying to alter the process in any way.

Belief systems are another matter. For instance, a common belief among artists is that drawing "more is better." A fully detailed, rendered-to-the-hilt presentation

DANIEL BENNETT SCHWARTZ

may indeed catch the eye before a simple, sparse rendition of the same subject. This response is true of professionals in the field as well as the nonartistic public. More lines, more work, more detail, more rendering, is just a question of more, not better.

This same belief holds true in other art forms as well. In a well-constructed play, for example, every line of dialogue further develops the plot or the characters. If the dialogue ceases to move the work forward, it serves no useful purpose. The play may seem boring and its wordiness may sacrifice the value already there. Overwork can strangle art rather than breathe life into it. Understatement can be more effective than overstatement.

Apropos of this is a true story about a successful humorous illustrator. He was called in by an advertising agency to meet with their new, ambitious art director. The art director was hoping to establish a "classy look" for a special new account. He

believed this distinguished cartoonist's style was recognizable and would achieve this goal. He explained the ad campaign to the cartoonist, showed him a layout for the print ad, and then they discussed fees. The art director was a bit surprised by the amount the cartoonist quoted, but he knew the account people agreed that this artist could offer the level of sophistication they were looking for.

A week later the artist came back with his finished drawing. Attached was his bill for services. The art director was both pleased and upset. "This is exactly the look we are after," he said. "But how can I go into the account executive's office and ask him for this much money when you did the drawing in only three lines?"

The artist answered, "If I could have done it in two lines it would have cost you a lot more!"

More is more, not better. Better is better. And if better means less, then obviously less is the way to go.

Looking at completed artwork is frustrating in that we only see the finished

stage. It's rare that we're privy to the evolutionary stages that enabled the artist to arrive at that graphic conclusion. If we are positively moved by the work, many of us, being the frail, vulnerable creatures that we are, say or think, "I wish I could do that." Or, "Will I ever be able to do that?" Or, worst of all (especially to someone early in their self-training), "I'll never be able to do that." Comparisons like these are problematic. In the first place, they assume the admired artist was born with that talent and never had to work hard to arrive at this mature, polished stage. Wrong! Chances are that at one time those artists had also uttered those *same words* when viewing the work of artists *they* admired. In the second place, novices comparing themselves to accomplished artists negate the importance of practice in the evolution of artistic development.

FRANK SOFO

FRANK SOFO

Itzhak Perlman's virtuosity has made him one of the most honored fiddlers on the roof. As accomplished as he is now, Perlman devotes as much time to practice today as he did years ago. Tennis champion Arthur Ashe also emphasized the importance of practice and taught beginners not to rely on their natural ability alone. What of Joe Montana's touchdown passes to Jerry Rice? Even in collaborative efforts, it's the same story. *Practice, practice, practice!* Why should it be any different for artists who draw?

Another popular belief is that all creative endeavors should begin with a well-conceived result. For example, artists should know exactly what their finished work will look like in the "mind's eye," or a composer should know what the complete score will sound like in the "mind's ear." This implies that all creative problems are resolved in the prepara-

FRANK SOFO

tory stages. Why? An idea is only an effective *starting point*. The evolving middle ground is where personal creativity has a chance to emerge. Artistic statements can be made, and ideas can be expanded in ways never anticipated. All artists, regardless of the creative vehicle they choose to express themselves, should allow that process to begin without fear or inhibition. Surrender to your natural, personal response and let it take you to where it wants to go. That destination is truly where you belong, and, more importantly, where you'll derive most satisfaction from your art.

Perhaps the concept most difficult for you to accept is that someone viewing your latest drawing may be thinking, "I wish I could do that." Scary, huh?

What do you say we give 'em a new sketch to look at? Better still, how about a whole bunch of new sketches from inside your sketchbook?

You realize, of course, I'm talking about your next . . .

ASSIGNMENT:
See You in Your Themes

While most of our spontaneous on-the-spot work is time-limited, extended works can become extended fun. Choosing a theme for a series of drawings offers a mounting experience of satisfaction.

1 Think about a subject that you'd enjoy doing several drawings about (for example, your pets, family, friends, places you visit) and set aside a new sketchbook or a section of clean pages in your present sketchbook.

2 Make as many drawings as you feel it takes to tell a complete story about that theme.

WILLIAM A. SMITH

A Flick of the Risk

Getting Careless?
Wonderful! Have a Ball!

TIM SHAMEY

Y ou know that nice, empty space on the wall in the hallway? That's a great place to hang a drawing! What's the problem? You don't have one you want to hang there? What's that? You have a drawing in your *mind* that would look perfect? *Don't do it!*

What *should* you do?

Go directly to chapter one, do not pass van Gogh, do not collect $200!

Why start back at the beginning?

Because you're not ready to accept drawing as a simple, natural response. *Draw*, don't *make a drawing.*

If you know what the finished art will look like from the start, you are stifling, limiting, restricting if not dismissing, eliminating, excluding completely salient qualities and energies in the creative process. You've slaughtered spontaneity, reduced responsiveness, and demolished discovery with a flick of the risk!

By not letting your drawing take over and go where it wants to go, it cannot expand to another (and possibly greater) level. When the approach is restricted to the execution of that completed, pre-determined image, it avoids and suppresses unpredictable stimuli, which could produce a far loftier achievement.

Personal work reacts to and incorporates new, ever-changing stimuli. Renderers (those who put technique before expression) *control*. Artists *lose control*. It's as simple as that. The satisfaction for a renderer is how close to the envisioned finished work he came. For the creative artist, it is a search for the unknown by way of an uncharted course through a constantly evolving horizon. It is a lot riskier to be sure, but the rewards are far greater.

Embracing the element of risk distinguishes the innovative from the predictable. Pablo Picasso said:

"A picture is not thought out and settled beforehand. While it is being done it changes as one's thoughts change. And when it is finished, it still goes on changing, according to the state of mind of whoever is looking at it. A picture lives a life like a living creature, undergoing the changes imposed on us by our life from day to day. This is natural enough, as the picture lives only through the man who is looking at it."

We can control the conscious, not the unconscious. With this in mind, it makes sense to make a conscious effort to get out of the way of our unconscious and let it do its thing. I'm aware that's quite a mouthful, but let's not make it a mindful. What's important here is that we respond more to what our subject is and less to what our subject looks like. If we capture what the model is doing and not what he looks like he's doing, our chances for creating a drawing that satisfies us will improve dramatically.

A "pose" tells us what someone looks like in a particular position, an *imitation* of an action, if you will. By responding to the action itself, even though we're limited in time and must rely partially on a "mind's

BRAD HOLLAND

eye" impression, we will at least get a sense of what the body is actually doing.

Art is a living experience that undergoes constant change during every moment of evolutionary process. Art is not a complete, fully realized entity, existing somewhere in a vast universe. Art is not waiting to make its grand entrance on the pad or canvas of some fortunate artist who happens to be in the right place at the right time. Don't leave it to luck, fellow artists. Winning the lottery is a lot easier than producing a masterpiece so, as we've said before, don't even try.

Some use techniques to eliminate risk as a means of gaining confidence. These attempts backfire. As an artist you lose con-

MARIE LAURENCIN

WILLIAM NEGRON

fidence when you are fearful of executing a "bad" drawing. By taking risks, a curiosity emerges that lends both innocence and naturalness to the work—"What will this look like?" is an infinitely more creative and exploratory process than the "I want it to look like this!" approach.

The paradox of caring enough to *not* care in drawing is analogous to many tasks we face in our lives. In sports, it's a known fact that tightening muscles to produce more power leads to contradictory results. The more one makes an effort to achieve (for example, hit a home run), the more tension created, thereby restricting

the natural physical response necessary for succeeding in the act. By reducing muscle tension and allowing fluidity of form, all the factors necessary to allow a batter to connect with the ball combine to make a home run possible. The same holds true in tennis. Trying to serve an ace is difficult for the typical weekend hacker. Once the muscles respond to the determination to "put one past an opponent's nose," they tighten and move into a state that is the antithesis of the loose, fluid motion necessary for an effective serve. Jerry Alleyne, an accomplished professional tennis player in his youth, taught enthusiasts like myself a "mantra" to accompany each individual serving motion. He made us repeat out loud the words, "I don't care!" to accompany the toss, contact, and follow-through stages of our serve. Not trying to serve an ace and just serving resulted in a lot more aces. By "not caring" you eliminate the conscious achievement factor and let the unconscious work.

In creating art, that same paradox holds true. The act of drawing can be most satisfying when we don't try to draw well. Listening to the voice of the critic within can stifle your natural flow of energy and talent. When an artist is truly free to see and feel without achievement considerations, he creates more personal, meaningful work. Ironically, this in turn actually increases chances for "success"—that very success he gave up striving for.

Earlier we discussed that a valuable choice to make is selecting "express" over "impress." The former deals with your individual statement, the latter deals with drawing for others, a poor substitute for personal satisfaction. But it isn't an easy choice to make.

FANTIN-LATOUR

We're all vulnerable to compliments. But if we examine those compliments with an objective eye, we find them to be less about us and more about peripheral commentary.

For instance, what is a typical response if someone says to you, "That's a nice shirt you're wearing"? If you are an average, civilized person, your response will most likely be a polite, "Thank you," and you'll let it go at that. But think for a moment about the scenario an obsessively introspective person might have regarding that same simple exchange. Their internal process might lead them to realize they haven't received a compliment at all, except in a limited way for having purchased the shirt. If the shirt had been a gift, then the person who purchased and gave it deserves that compliment. Taking it to the next level: the greatest part of the compliment should actually be shared by the clothing designer and the manufacturer, for it is their creation, not yours.

If someone compliments us on what is indeed our own creation such as a drawing, we want the compliment to validate our talent, something that words cannot, and more importantly, should not do. Unfortunately for most of us sensitive, vulnerable creatures, the simple "thank you" route is the road least followed.

Sometimes, someone looking at *your* drawing will "compliment" you with a typical self-oriented pearl: "*I* can't draw a straight line with a ruler!" Who cares? What's that got to do with the drawing I'm showing you?

Self-discipline is difficult (if not impossible) until you have accepted reality. The process isn't about decision-making. You can

PAUL CÉZANNE

promise yourself you'll stop smoking tomorrow morning, but the moment that decision is made seldom marks the exact moment you've achieved your goal. You only need to draw to be an artist. To be a lucrative artist you need luck. Those are two very different and separate dynamics.

The serious drawing student can actually retard his growth as an artist by trying to learn too much about the working methods, procedures, and techniques of others. This is a futile task since most of the "information" one seeks to accelerate growth isn't worth the time dedicated to that pursuit. That same time put to use in the primary activity, drawing, is where actual growth takes place.

There are no rules in art. As soon as a rule appears, someone comes along and breaks it. If the penalty for an art rule infraction was death, they would have had to execute each and every Impressionist.

This reality, of course, drives many students bonkers. They devote so much time and energy in pursuit of a method that will ensure a successful drawing. At some time in their drawing life, hopefully sooner than later, they will realize that it just can't be done.

It is always wiser to avoid any attempt to do a "definitive" work. Approach each session as if it is one of countless others to follow and never treat each drawing as an opportunity to showcase the totality of your talent.

Always draw what you see. The subjective interpretation of your vision will emerge unconsciously to make it a personal statement.

AUGUSTE RODIN

There is no reason to force or contrive that personal statement. Let it happen *naturally*. It will happen *if* you allow it to.

Analyzing "technique" is best left to the critics and educators of art history since it serves little positive purpose for the artist. For example, breaking down the elements of brushstrokes and materials can supply answers about when and where a work was executed. This is necessary for museum curators, gallery administrators, and art-book publishers. But if the artist becomes too absorbed in such matters he may unwittingly become influenced in his approach and begin to favor imitation rather than original expression.

There are two major realms in the world of imitation: imitation of others and imitation of oneself. Neither is looked upon with positive judgment (except by the imitator who often feels varied degrees of achievement in how close they've come to the original). The critics note of the first, ". . . so derivative of the works of Whosisface that if there was an original statement at the onset, it was lost in a swirling sea of style and technique." And of the second, ". . . so derivative of his own past work that it was lost in a swirling sea of self-consciousness and redundancy." It's also important to notice how we never listen to critics unless we just happen to agree with them!

Risk is inherent in all art forms if the artists involved are willing to address it. Imitation is the antithesis of risk in that it provides a safety net of established and accepted solutions. Edward Albee, a playwright always willing to push the envelope further, has said this about fellow playwright Sam Shepard: "Sam was always taking

CAMILLE PISSARRO

chances, always being original. Somebody who was willing to fail and fail interestingly. And if you're willing to fail interestingly, you tend to succeed interestingly."

Drawing from within offers a context through which the depths of our talents can be tapped and satisfaction from our personal drawing experience can be realized without complex learning procedures, formulas to memorize, methods to follow, or techniques to master. That context is the individual's natural drawing response. It is actually a *nonapproach* approach that offers total support for you in your search to find who you are on paper, which is, in the final analysis, *everything*.

As to how you look on paper, well that's another story. Actually, it's your last . . .

ASSIGNMENT:
Through a Glass Starkly

The best is last to come. Your final assignment is a por-

trait of *you*. And what artist better suited for the task

than yourself?

1 On separate sheets of paper, make several studies of
 yourself from a mirror image (not
 photographs!).

2 Make a composite drawing
 utilizing your favorite self-
 image to start with, then
 drawing those items you
 choose to include from
 the previous chapter.

SHELLY SACKS

Afterword

e've read some words and looked at some drawings by world-famous artists from another era and artists of today as well as some artwork done by "nonprofessionals." We've viewed hands drawn by an Impressionist, several successful illustrators, and a clinical social worker (when she was thirteen years old). We've seen work done on the spot from prison cells to the wings of the Metropolitan Opera House (with Luciano Pavarotti signing a drawing of himself—"I enjoy very much your sketch").

What have we learned from the words and the drawings? Very little in the way of the academic process. More important is the lesson that can be learned from the single thread that weaves

these pages together. Every piece of art presented here was done with enjoyment and was drawn for the sheer pleasure of it. That satisfaction is available to all who are willing to draw as a natural response to their individual experiences.

The drawing surface has been and always will be where the artist's real education takes place. So if it's learning you're after, close this book and open to the pages that will really teach you what you want to know. Your own sketchbook.

Enjoy . . .

NICK MEGLIN

Index

A

abstract, 63, 65
achievement, 35–36, 46
 measuring, 35, 38
 and risk, 232, 234
 and success, 226
action, capturing, 135, 223
art education
 instructors, 42–44
 types, 12
art shows, 41
artists
 achievement, 35–36, 38
 in courtrooms, 77, 80
 craft, 169–171
 defined, 96
 individuality, 27, 35, 126
 influences on, 53, 56, 187
 losing confidence, 200, 224–225
 motivation, 53
 natural response, 51, 73, 75, 221
 novice, 199
 personal statements, 30, 216, 230
 versus scientists, 59
 vision, 199
 visual stimulation, 85

B

body language, 135, 150
brushes, 30

C

composition, 203
contour sketch, 151
corrections, 25
 from instructor, 44
creative process, 207–208, 210
 final results, 215–216
creativity, 74, 89, 118
 origins, 207–208
 of photographers, 132
 restrictions on, 131, 149, 222
 and subjectivity, 115, 117–118
criticism, 112–114
 versus judgment, 41, 42
critics, 112–113
 self as, 114, 115

D

details, 121

drawing
 accuracy, 121, 149
 environment, 75, 77, 163
 guidelines, 199
 how-to, 11, 12, 170
 initial stages, 17–18
 learning, 11, 12, 175
 mastery, 18
 naturally versus intellectually, 53, 55–56
 on-the-spot, 56, 77, 80, 91
 perfection, 119, 200
 for pleasure, 80, 96
 practicing, 213, 215
 responsive, 71, 85, 103, 106
 time for, 155–157, 159–161, 163

E

education, art
 formal, 12
 instructors, 42–44
 self-taught, 12, 14
environment. See setting
erasing, 25, See also mistakes
exercises. See assignments
exhibitions, 41

F

Fellini, 81, 82
fountain pens, 22, 24, 25
Frazetta, Frank, 27, 28

I

idealization, 99, 199
imagery, 62, 82
imitation, 35, 53, 55, 183–184
 versus inspiration, 185
 of oneself, 232
impressionism, 86
inanimate objects, 101, 121
individuality, 27, 35, 126
inspiration, 53, 185
instruction. See art education

J

judgment
 of art, 41, 112
 versus criticism, 42, 112, 113

L

life drawing, 128
location, 91, See also setting

M

materials, 17–18, 24, 30, 80
 and results, 20, 21
media. See materials
mistakes, 24, 25
 and awareness, 195, 201
 and criticism, 42
 learning from, 193, 197
motion, capturing, 135

N

nature
 idealization, 99
 improving on, 99
 light and shade, 129–130

O

objectivity, 59, 112
 and perception, 143
on-the-spot drawing, 56, 77, 80
 assignment, 91

P

pencils, 30
pens, 22, 24, 25, 30
perceptions, 86, 141, 143
personal experience, 143–144
personal satisfaction, 35, 59, 89
 and achievement, 38
 and goals, 46
photographs
 and creativity, 131
 and dimensionality, 128, 130
 replication, 14
Picasso, 222
proportions, 139, 141

R

realism, 121
Rembrandt, 18
rendering, 17, 20, 174, 183
 overstatement, 210–211
responsive drawing, 71, 75, 85, 103

S

Schulz, Charles, 36, 38
self-expression, 14, 120, 149
self-judgment, 66, 115
self-teaching, 11, 12, 14
setting, 73
 assignment, 91

 exterior, 91
 interior, 91
Seurat, George, 86, 89
sketchbooks, 77, 80, 84–85, 125, 126
 definitive works, 132
sketching. See drawing; sketchbooks
Sondheim, Stephen, 85–86
spontaneity, 53, 71
studio, 75, 163
subjectivity, 59, 101, 118
 bad art, 115
 and creativity, 115, 117–118
 and perceptions, 141, 143
subjects
 choosing, 95, 103
 human forms, 101
 inanimate objects, 101, 121
 posing, 223
 variations on the same, 102–103, 105
success. See achievement

T

talent
 individual, 13, 55
 validating, 56
techniques, 14, 17, 174, 232
three-dimensional, 129
tools. See materials
Toulouse-Lautrec, Henri, 139, 141

V

van Gogh, 18, 20, 171
variance, 117

FRANK SOFO

The best in fine art instruction and inspiration is from North Light Books!

Drawing people is more than just accurately capturing the anatomy and details of the subject. Artists who capture the soul of the model breathe life into the artwork by expressing a mood, idea or emotion that cannot be captured by accurate rendering alone. *Life Drawing* will give you all the tools necessary to draw people accurately and expressively, setting it apart from books that teach technique only. A variety of materials (nupastel, charcoal and graphite) will be used to give you a range of options to choose what works best for the subject of each drawing.

ISBN-13: 978-1-58180-979-4
ISBN-10: 1-58180-979-4
Hardcover, 160 pages, #Z0813

Children are one of the most popular yet difficult subjects for artists. Capturing their emotions and delicate features is often intimidating. Whatever age or skill level, even if you think you can't be taught, you will learn how to draw incredibly realistic children in basic black and white with time-tested drawing principles refined into a foolproof program by authors Carrie Stuart Parks and Rick Parks.

ISBN-13: 978-1-58180-963-3
ISBN-10: 1-58180-963-8
Paperback, 128 pages, #Z0687

Work at your own pace, enjoying the friendly and experienced instruction from Dr. Mary on all aspects of drawing, including composition and design principles. With compassion and some humor, *The Little Book of Drawing* will help you to achieve your goals to draw proficiently and express a personal style. You'll not only learn how to draw, but will learn to see like an artist, the key skill to making art. Basic contour drawing, value and texture will be discussed with lessons on the figure, composition and working from life on location.

ISBN-13: 978-1-58180-885-8
ISBN-10: 1-58180-885-2
Hardcover, 144 pages, #Z0491

These books and other fine North Light titles are available at your local fine art retailer or bookstore or from online suppliers. Also visit our website at www.artistsnetwork.com.